Chicago
New Media
1973–1992

jonCates

Chicago New Media 1973-1992 is published in conjunction with an exhibition of the same title, curated by Jon Cates with assistance from Chaz Evans and Jonathan Kinkley, and organized by Video Game Art Gallery in partnership with Gallery 400 at University of Illinois at Chicago and with the support of the Electronic Visualization Laboratory. It is presented at Gallery 400 from November 1–December 15, 2018.

Major support for this project is provided by the Terra Foundation for American Art. It is part of Art Design Chicago, an exploration of Chicago's art and design legacy, an initiative of the Terra Foundation for American Art with presenting partner, The Richard H. Driehaus Foundation. Additional generous support for this project is made possible by The Chicago Community Trust and the Goethe-Institut Chicago.

Published by
Video Game Art Gallery
2418 W Bloomingdale Avenue #102
Chicago, IL 60647
www.vgagallery.com

Distributed by
University of Illinois Press
1325 South Oak Street
Champaign, IL 61820-6903
www.press.uillinois.edu

Produced by Video Game Art Gallery
Edited by Tiffany Funk
Design by Ohn Ho

First edition
Printed in the United States

ISBN: 978-0-252-08407-2

Chicago New Media
1973–1992

Curated by jonCates

video game art
gallery

Contents

Dan Sandin, Tom DeFanti and Mimi Shevitz
Detail of Spiral 5 PTL (Perhaps The Last), 1979
Video

Directors' Foreword

Chicago is a vital center for new media art, technology, and industry, though its historical and present contributions remain under-recognized. The achievements of artists educated at the University of Illinois at Chicago and the School of the Art Institute of Chicago and developed across town in the private sector in the offices and warehouses of pinball and video game titans Bally, Williams, and Midway are chronicled in the following pages and in the exhibition Chicago New Media 1973 - 1992, the first project to link these communities during this period.

Chicago New Media 1973 - 1992 is organized by Video Game Art (VGA) Gallery—the city's leading art organization devoted to new media and video games—in partnership with Gallery 400 at University of Illinois at Chicago (UIC), a critical center for contemporary art, architecture, and design at the university that is birthplace of the legendary Electronic Visualization Lab (EVL). The project is curated by a remarkable and uniquely-suited individual at the center of the city's new media community: Jon Cates, artist and Associate Professor in the departments of Film, Video, New Media and Animation, and Art History, Theory and Criticism at the School of the Art Institute. As one of the first students of Media Art Histories, a graduate program founded at Donau-Universität Krems by art historian and early new media scholar Oliver Grau, Cates is an archivist, preservationist, and scholar of Chicago new media, promoting the city's distinctive history in his research. That Cates hails from the School that trained generations of new media artists in early and significant video art, generative systems, and sound art programs makes him especially suited to write the book on new media art in Chicago. With one foot in history and one foot in the future, Cates has shown extraordinary passion and energy in tackling this challenge, and the project has benefited immensely from his network, intelligence, and creative vision.

UIC's EVL was an early and indispensable partner. We were fortunate to have the critical assistance, insight, and participation of artists and EVL co-founders Tom DeFanti and Dan Sandin. Current EVL leaders were especially helpful and supportive as partners. Special thanks to Director Maxine Brown, who leads the storied lab in the 21st century, and to EVL Associate Director Dana Plepys, a new media artist in her own right and the Lab's liaison to the project.

At VGA we would like to thank Chaz Evans, VGA Co-Founder and Director of Exhibitions and Programs, who provided curatorial assistance and programming scheduling; Tiffany Funk, Editor-in-Chief of the VGA Reader, a peer-reviewed journal focused on video game art, history, theory, and criticism, who was a critical project sounding board and editor of this catalog; Brice Puls, who has brought technical wizardry and preparatory expertise to installing this media intensive exhibition; Maureen Ryan, whose communications expertise expanded the reach of this initiative; and interns Sean Leftwich, Irene Roh, and Katie Kearney for their assistance.

Gallery 400 and University of Illinois at Chicago is grateful for the significant contributions of Assistant Director Erin Nixon; Community Engagement and Public Programs Manager Marcela Torres, graduate assistants Karen Greenwalt, Erin Madarieta, Megan Moran, and Rachel McDermott; preparators Nate Braunfeld, Kyle Schlie, and Alexandra Schutz.

Our greatest thanks go to the brilliant and inventive artists, scientists, developers, and participants listed below. We are extremely grateful to our institutional partners and lenders, including the University of Illinois Press, especially Daniel Nasset and Michael Roux; the Illinois Institute of Technology's Paul V. Galvin Library, with special thanks to Adam Strohm and Ralph Pugh; Chicago History Museum, with special thanks to Julie Katz and Joy Bivins; The Daniel Langlois Foundation, especially Ludovic Carpentier; George Spanos at Izzy's Arcade Bar; Hank Kaczmarski at Illinois Simulator Laboratory at University of Illinois Urbana-Champaign; and Trish Stone at Gallery @ Calit2.

The chief author of this publication is Chicago New Media curator Jon Cates, who worked tirelessly with editor Tiffany Funk and designer Ohn Ho to produce this handsome volume. These brilliant and talented individuals all hold our deepest appreciation and admiration.

This project is funded by the Terra Foundation for American Art. It is part of Art Design Chicago, an exploration of Chicago's art and design legacy, an initiative of the Terra Foundation for American Art with presenting partner The Richard H. Driehaus Foundation. Additional generous support for this project comes from The Chicago Community Trust. We are deeply grateful to Elizabeth Glassman, Amy Zinck, Jennifer Siegenthaler, Annie Cullen, Eva Silverman, and Maureen Jasculca at the Terra Foundation; Helene Gayle, Eva Penar, Sandra Aponte, Cora Marquez, and Nestor Avendano at The Chicago Community Trust; and Kim Coventry, Geoffrey Banks, and Suellen Burns at the Driehaus Foundation. In-kind support is provided by the Goethe-Institut of Chicago; we are grateful for Irmi Maunu-Kocian's involvement.

It is our privilege to honor the artists and makers who forever changed the face of art, technology, and design in Chicago and the world. Our profound hope is that the rich and visionary legacy of this inventive era will be etched in the memories of this project's visitors and readers, and that the exhibition and catalog will serve as platforms and inspiration for future video game and new media artists from Chicago and beyond.

Jonathan Kinkley
Co-Founder and Executive Director
VGA Gallery

Lorelei Stewart
Director, Gallery 400
University of Illinois at Chicago

Chicago New Media 1973-1992 exhibition artists, scientists, developers, participants and symposium presenters include:

Alex Hill
Andy Saia
Anna Anthropy
Annette Barbier
(art)n
Azadeh Gholizadeh
Bally Manufacturing/
 Entertainment
 Corporation
Barbara Sykes
Barry Brosch
Beth Cerny Patiño
Bob Snyder
Brenda Lopez Silva
Bulletin of the Atomic
 Scientists
Cardboard Computer (Jake
 Elliott, Tamas Kemenczy
 and Ben Babbitt)
Carolina Cruze Nevera
Cat Bluemke
Chicago History Museum
Chip Dodsworth
Chloe Krouse
Chris Hartman
Chris Kemp
Christiane Paul
Copper Giloth
Craig Ahmer
Dan Neveu
Dan Sandin
Dana Plepys
Dave Pape
Diana Torres
Dick Ainsworth
Doug Lofstrom
Drew Browning
Ed Boon
Electronic Visualization Lab
Ellen Sandor

Essanay Studio
Eugene Jarvis
Geoffrey Allen Baum
George Francis
Glen Charvat
Greg Dawl
Guenther Tetz
Harold Walter
IIT Archives, Paul V. Galvin
 Library
Jackbox Games
Jamie Fenton
Jan Heyn Cubacub
Jane Veeder
Janine Fron
Jason Salavon
Jeffrey Daniels
Jim Teister
John Hart
John Tobias
Joseph Tremonti
Josephine Anstey
Josephine Lipuma
Josh Tsui
Keith Miller
Larry Cuba
Larry DeMar
László Moholy-Nagy
Laurie Lou Kauffman
Laurie Spiegel
Leif Brush
Louis Kauffman
Margaret Dolinsky
Marientina Gotsis
Maxine Brown
Midway Manufacturing/
 Games Inc.
Mimi Shevitz
Nancy Bechtol
Natalie Bookchin

National Center for
 Supercomputing
 Applications
Nick Briz
Oliver Grau
Petra Gemeinboeck
Phil Morton
Rachel Bronson
Raul Zaritsky
Richard Mandeberg
Richard Sayre
Rick Panzer
Rylin Harris
Sabrina Raaf
Sara Ludy
School of the Art Institute
 Chicago
School of Design, Chicago
Siebren Versteeg
Sonia Landy Sheridan
St. Louis Post Dispatch
Stephan Meyers
Sticks Raboin
Stu Pettigrew
Sumit Das
Tim Portlock
Todd Margolis
Tom DeFanti
University of Illinois at
 Chicago
Whitney Pow
William Robertson
Williams Electronics, Inc
Ya Lu Lin

Phil Morton
Detail of COPY-IT-RIGHT

Curator's Introduction
jonCates

I begin by acknowledging that this exhibition and its events are being held on the traditional lands of the indigenous First Nations People, including the Ojibwe, the Potawatomi, the Miami, the Kaskaskia and the Peoria Nations. I pay my respect to the land, the elders, and the people, as well as their past, present, and future leaders.

In the recent book *New Media Futures: The Rise of Women in the Digital Arts,* edited by Donna Cox, Ellen Sandor, and Janine Fron, Jane Veeder refers to an "entire creative culture" that formed in Chicago during the decade of the 1970s.[1] This creative culture of collaborative communities gathered together regularly to perform in various configurations publicly during annual Electronic Visualization Events on the campus of the University of Illinois at Chicago (UIC). Their connections were social, artistic, educational, and technological. As Veeder recounts, the new media arts community formed in Chicago around a shared set of open, technosocial theory-practices that fostered ethical commitments through new kinds of art, novel in their form and content, as well as in the subjectivities they produced. These artists, scientists, and developers were also teachers, students, and co-creators of new schools of thought. Their energy and environment of collaborative co-creation literally built these systems from scratch. They lived through and with these systems, electronically processing and projecting themselves into their futures' present.

Chicago New Media 1973 – 1992 cannot fully render — or rather, compute — a complete view of the hystories and genealogies of new media art and video games, intersecting here in what the Miami called Shikaakwa (which may mean the wild onion or garlic now known as "ramps"). We are located on traditional lands in a geographic region where civilizations have existed for at least 7,500 years. My intentional spelling of "hystories" substitutes a "y" for an "i" to purposefully recenter our attention to emphasize how hystories are always compromised by the writing of the historical project itself. They are a patchwork of accounts and recollections. In addition, I use the plural forms of the terms "hystories" and "genealogies" to underscore how both are formed from multiple accounts and experiences, thus making it possible that parallel hystories may contentiously compete and/or harmoniously coexist. Hystories are by nature partial and incomplete; parts will be missing, and people who should be included are unfortunately not. Still, we believe this undertaking to be special, and much-needed. My project in this exhibition, its events, and this writing is, to use the language of Ted Nelson, "a vasty tingletangle" of "hyper-threaded" hystories that we will navigate together and "on our owns."[2] Ideally, this exhibition and its events will complicate the assumed newness of new media and present various views into the people, contexts, and processes that constitute new media art and games in Chicago.

The people of these hystories are either based in, or connected to and/or through, Chicago. 1973 to 1992 is the central core from which our project spirals out of and into *Chicago New Media Art and Games.* 1973 marks the beginning of an unprecedented period of innovation in Chicago New Media: Phil Morton and Dan Sandin performed their *Inconsecration of New Space* on Sandin's newly invented Image Processor, Tom DeFanti joined the faculty at the University of Illinois at Chicago (UIC), the Circle Graphics Habitat was established by

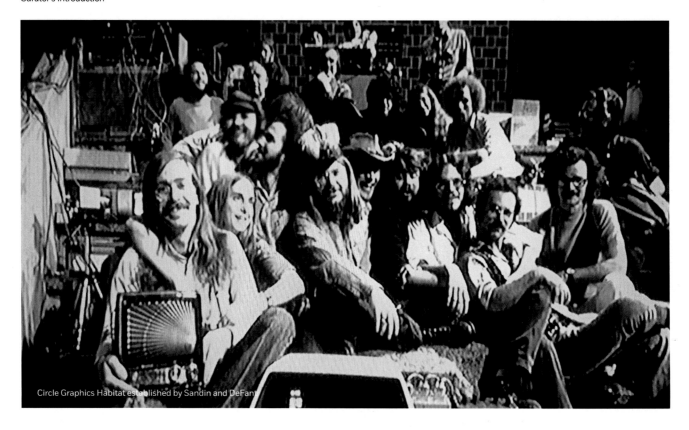
Circle Graphics Habitat established by Sandin and DeFanti

Sandin and DeFanti (later renamed the Electronic Visualization Lab, or EVL), and Ted Nelson, while enmeshed in these Chicago creative communities, wrote his pro- foundly influential book *Computer Lib/Dream Machines*. The events of 1992 celebrated in this exhibition constitute a kind of new media apotheosis: Mosaic, the first web browser, was developed at the University of Illinois' Champaign- Urbana campus at the National Center for Supercomputing Applications (NCSA), the video game *Mortal Kombat* was created in Chicago, and Ars Electronica's exhibition in Linz, Austria featured "Pioneers of Electronic Art" including the work of both Sandin and Morton.

As our project celebrates the efforts, energies, and commitments of the Chicago new media community, it is crucial that we recognize the behind-the-scenes Chicago- based artists and developers who fundamentally transformed new media art and video game production both locally and worldwide. Chief among them is Jamie Faye Fenton, whose work in developing software systems

made so much experimental media art possible. Our timeframe, 1973 to 1992, bookends an especially prolific and influential production period for Fenton: she began creating video games in 1974, developed the operating system and programming language for the Bally Arcade Video Game System in 1977, co-founded MacroMind (1984), and developed the VideoWorks software (1985) that would eventually become the Director multimedia authoring software (1987). By the 1990s, Director became the software of choice for new media artists creating interactive multimedia projects, art, and games on CD-ROM and the Web. Fenton, as the developer of the Director software, facilitated unprecedented experimental and independent artist-driven software distribution.

Prismatically extending and expanding from the exhibition, the people, and events of Chicago New Media is a discursive effort, crossing multiple subjectivities and intergenerational creative communities. To tell these hystories, I am stitching the patchwork, making a

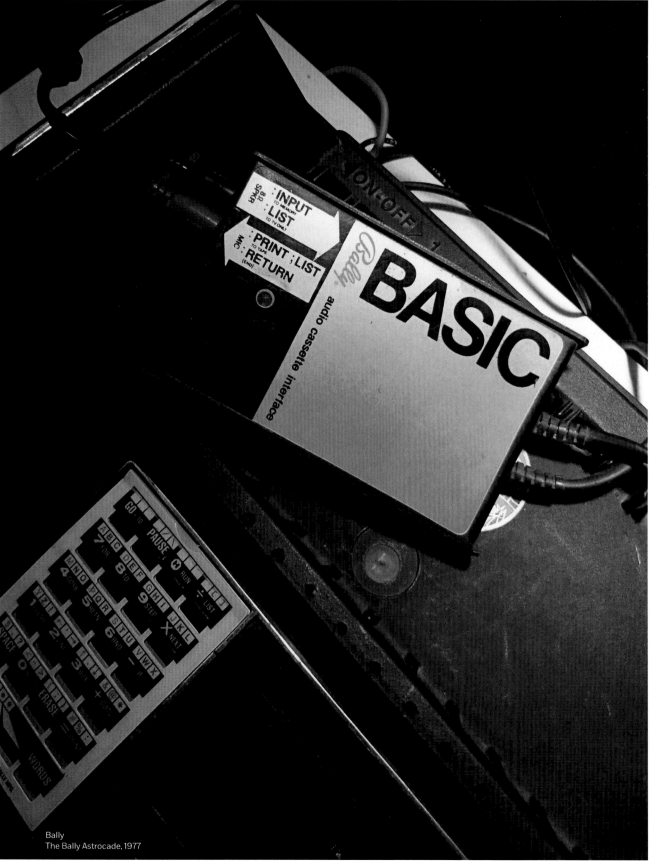

Bally
The Bally Astrocade, 1977

meshwork, and playing a game based on rulesets. I will bend, if not break, a few of these rules: for instance, I have stretched beyond the date range in the title of the exhibition. Chronologically and geographically, our exhibition begins in Chicago: our oldest work is a film still from 1910, shot on the set of a Broncho Billy silent film at the Essanay Film Studio, now a historic landmark in the city. Our most recent work includes projects that are being rendered as I write this text in 2018, such as Sara Ludy's *Sky Canyon* series. Many, many works exist in the times between, too many to count, name, or discuss in detail within this essay or exhibition. We have, however, made every effort to list all participating artists and entities in the materials of the exhibition, our catalog, and timeline. As such, we have an important purpose ahead of us: to bring together voices that speak to ongoing contributions at the intersection of art and games in Chicago.

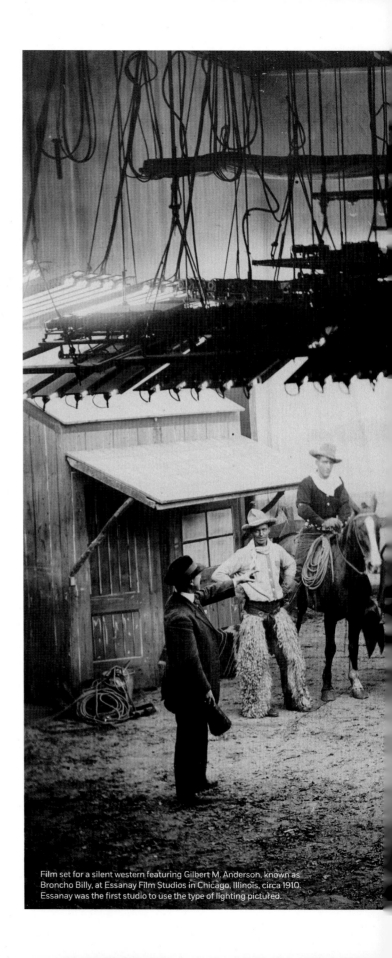

Film set for a silent western featuring Gilbert M. Anderson, known as Broncho Billy, at Essanay Film Studios in Chicago, Illinois, circa 1910. Essanay was the first studio to use the type of lighting pictured.

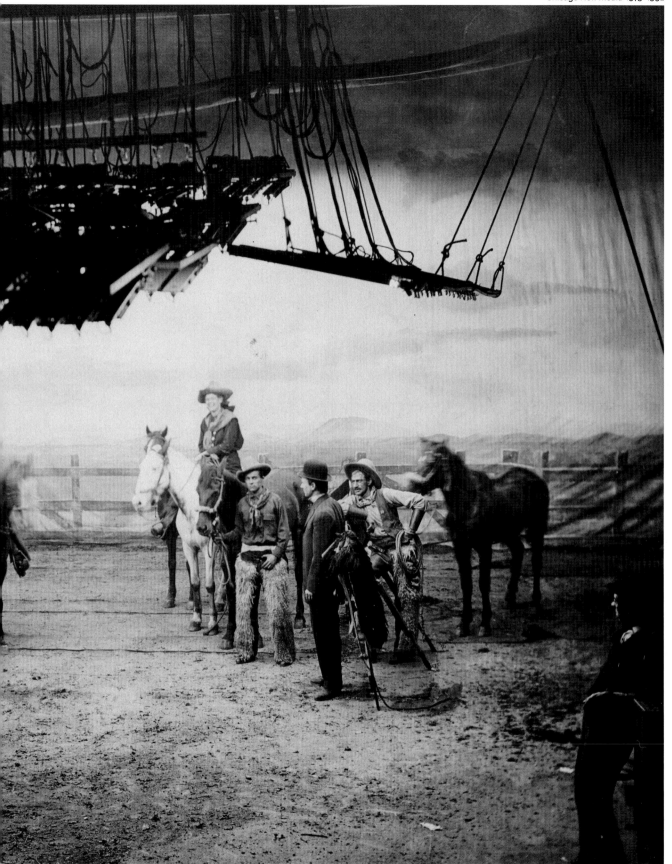

Nancy Bechtol
Detail of Native Dance Vibrations, 2007
Video

16

Media Art Hystories and Genealogies of Art and Games

Prehystories

How did we arrive at this time and place? Who belongs to these genealogies, and what do their contributions reveal about our present? The pioneering media artist Jane Veeder once told me that I came to her in search of my own media art hystories and genealogies in order to know who I am and where I came from. She also confirmed our shared genealogical links to countercultures of the past; just as Phil Morton's COPY-IT-RIGHT ethic came from "an early counterculture … sense that information should be free," the ethical positions and subjectivities we now celebrate in new media art are what connects us to the past.[3] Configurations of key events woven through with artists and game developers, organizations, collectives, individuals, small businesses, and major corporations all provide insight into this interconnectedness of Chicago New Media.

In the evening of January 17, 1961, just prior to his departure from the Presidency of the United States, then-President Dwight D. Eisenhower warned against the "grave" threat to democracy and liberty: the "military-industrial complex."[4] When he gave this farewell address, these forces were already in the rapid process of establishing "a permanent armaments industry of vast proportions" with unprecedented influence. During the following years, the RAND Corporation, a perfect example of the military-industrial complex Eisenhower warned against, built ARPANET, the core infrastructures and technologies we know today as the Internet. The birth of ARPANET is one among many computer science innovations in the 1960s: Ivan E. Sutherland's Sketchpad for computer interactivity, developed at the Massachusetts Institute of Technology (MIT), and his Ultimate Display for Virtual Reality; Ken Knowlton's BEFLIX language for Computer Animation, developed at Bell Labs; the "Mother of All Demos" by Douglas Engelbart and his team at the Stanford Research Institute at Stanford University; as well as Alan Kay's Dynabook personal computer. The military-industrial-academic complex, driven by these innovations, made Eisenhower's warnings a reality. These machines and systems operated on every level of society to fundamentally transform it: market forces delivered people, individually and collectively, to these machines, systems, and assemblages through the rapidly coalescing concepts of "personal computing" and "consumer electronics."

As a result of these innovations, the following global events of the 1960s and 70s caused individuals worldwide to rethink and rewrite human potential: the American wars in Vietnam, Laos, and Cambodia (and the unprecedented ways in which these brutal conflicts were televised); the Soviet space exploration program in present day Russia; the civil rights movement and political assassinations in the United States; Marshall McLuhan's academic work in Canada; the Cultural Revolution in the People's Republic of China; the general strikes, public protests, and occupations of universities and factories in Paris and across France; and the Prague Spring. Though this list is undoubtedly incomplete, the scope of these events gives us some context to understand the individuals, events, systems, commitments, communities, art, and games that form the central orbit of this exhibition.

In the mid-1960s, SONY introduced the Portapak into the market and the practices and artifacts of television production became smaller, more personal, direct, idiosyncratic,

differently political, artistic, and unpredictable. A parallel change had already occurred earlier in audio capturing with reel-to-reel recording and playback decks: the German company UHER introduced their 4000 Report series of professional and portable stereo open-reel magnetic-tape audio recorders and playback decks. The SONY Portapak expanded on the form and functionality of the UHER 4000 Report series; because both product lines could be carried by one person in a strong, over-the-shoulder leather satchel, they were quickly adopted for political, journalistic, artistic, and media production purposes. These machines allowed people to operate independently, in self-directed experiments. Both systems enabled nearly immediate playback. Famously, early-adopter Nam June Paik used both devices in artworks and projects, signaling the experimental possibilities of new media art for decades to come.

However, the portable typewriter preceded both of these portable audio and video recording technologies by almost one hundred years. When they entered the marketplace in the late 1800s, these devices recoded writing in ways that rivaled the cultural impact of the miniaturization and subsequent personalization of the printing press. Personal written communications were already being sent via the existing technology of the telegraph, and then over an international network linked by transatlantic telegraph cable. Voice-to-voice communications followed via the technology of the telephone, bringing people the immediacy the Portapak later delivered to the emergent art form that became video art. Computing followed similar trajectories: once heavily-guarded, financially inaccessible, and fortified within institutions in alliance with the military-industrial-academic complex, computers are now nearly everywhere. The miniaturization of consumer electronics has led to the powerful and persistently-networked computing power many of us carry in our pockets. A commitment to small-scale technologies for personal transformation—to paraphrase Fred Turner on Stewart Brand—powers this sense of self-determination and the internalization of technosocial possibilities.[5] We are brought together by these technosocial systems while we are also encouraged to individually explore who we are. A radical turn toward unprecedented opportunities for change provided new pathways for expanding consciousness and collective will through the creation of new genres, voices, and visions of art.

Annette Barbier and Richard Mandeberg
Detail of Speak to Me Softly, 1977
Video

Communities

The collaborative new media arts communities formed in Chicago through symbiotic needs, members augmenting each others' existing or complementary skills while engaging ethical and social concerns of the era. The new media artforms that they authored—video art, video games, and experimental electronic music—were made using systems amenable to collaborative practice, such as the Sandin Image Processor, the Bally Home Computer Arcade (later known as the Bally Astrocade), and the GRASS and subsequent ZGRASS computer programming languages. The Sandin Image Processor, a modular patch-programmable analog computer optimized for processing or synthesizing audio and video signals, was created by Dan Sandin (of UIC) and documented by Phil Morton of the School of the Art Institute of Chicago (SAIC), and made distributable via an open source ethic and anti-copyright approach Morton called COPY-IT-RIGHT. The Bally Home Computer/ Arcade System was one of the first affordable home computers and video game platforms to be released in the United States by the Chicago-based company Bally-Midway. The GRASS programming language, a powerful computer graphics language, was developed by Tom DeFanti (UIC). GRASS led to ZGRASS, the language collaboratively developed by DeFanti, Jamie Fenton, and Nola Donato (then of UIC, presently of Samsung).

Many artists, scientists, and developers were and continue to be instrumental to these foundational Chicago creative communities. An abbreviated list includes the aforementioned folks—Sandin, DeFanti, Fenton, Donato, Morton, Veeder, Nelson—as well as those participating in this exhibition: Bob Snyder, Ellen Sandor, (art)n, Larry Cuba, Copper Giloth, Barbara Sykes, Annette Barbier, Kate Horsfield, Lyn Blumenthal; Guenther Tetz, Ginny and Stu Pettigrew, Laurie Spiegel, Rylin Harris, Janine Fron, Nancy Bechtol, Maxine Brown, Dana Plepys, Marc Canter, and Mark Stephen Pierce, and their extended networks, i.e. Charles Csuri, Gene Youngblood, Stan Brakhage, Steina and Woody Vasulka, to name only a few. From all of these colleagues and contemporaries, teachers and students, to the founders of academic programs that came before them in Chicago—such as László Moholy-Nagy and his foundational work at the Illinois Institute of Technology (IIT) in the 1930s and 40s—it becomes increasingly evident that schools provided much of the framework for these fledgling creatives. IIT, UIC, SAIC, and others acted as incubators for the ideas and approaches of these Chicago communities.

In 1978, Jamie Faye Fenton created *Digital TV Dinner* in collaboration with Raul Zaritsky and Dick Ainsworth. Over thirty years later, on October 8th, 2009, she published this artwork on YouTube. Since its creation in 2005, YouTube has become a massively influential space for collaboration. Amongst all the contributions in this immense technosocial space of interaction and influence, glitch artists claimed Fenton's work as one of the earliest known instances of glitch art. As I know from my own experiences of making the unstable arts in the 1990s—before the category "glitch art" existed—Fenton's early work anticipated the core explorations and interventions of what would eventually become glitch art. Communities forming around these approaches were based in Chicago (as Fenton was herself when she made *Digital TV Dinner),* but also globally, across decentralized networks. Nick Briz's Apple Computers, which I commissioned five years ago for the

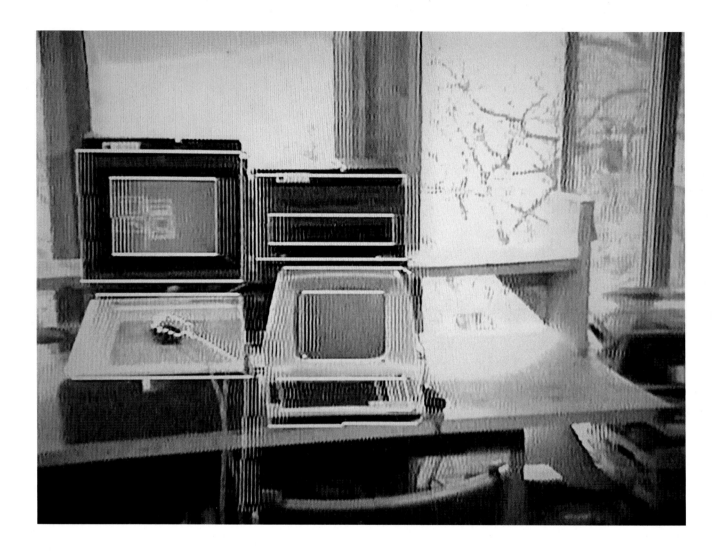

REMIX-IT-RIGHT exhibition, provides a partial view into the outcomes of Fenton's project. Apple Computers is itself a survey of Chicago new media through the lens of glitch art in 2013, capturing on camera a wide range of artists based in Chicago while Briz literally reenacts and reinterprets Phil Morton's General Motors.

General Motors is Morton's most well-known and widely distributed artwork, having been released in its entirety online by the Phil Morton Memorial Research Archive.[6] An intense "conversational video," as Morton referred to his projects, he confronts power, labor, and class relations while articulating a position that Bob Snyder has called Morton's "Emersonian idea of technological self-reliance." Morton's artwork makes extensive and masterful use of the Sandin Image Processor, GRASS computer animations, and performances of direct address via Morton's character of "CROSSEYE." General Motors is itself a cyber-psychedelic adventure into convivial tools for technosocial transformation, critiquing consumer culture in powerful, playful, sprawling, excessive, and experimental ways. In it, Morton details specific technical problems with his newly purchased General Motors van while intercutting computer animations made with DeFanti's GRASS programming language and images processed with the Sandin Image Processor as cyber-psychedelic illustrations. These GRASS animations become abstract representations of problems such as the "Vent Window Latch" breaking, "Vent Window Support" falling off, the "Hood Misalignment" of the truck or "PCV Valve Bolt" that was missing when Morton originally purchased the van. Each illustration serves to remix and rework his reality in the context of his Image Processing masterpiece.

Jake Elliott of Cardboard Computer (Elliot, Tamas Kemenzy, and Ben Babbitt, creators of the game *Kentucky Route Zero)* has described the Sandin Image Processor as an "artist-made tool for reprocessing reality."[7] Kemenczy recreated the patch-programmable Sandin Image Processor in HTML to run as a simulated emulation in web browsers. Most recently, Cardboard Computer simulated a Sandin Image Processor in their game *Un Pueblo de Nada,* a *Kentucky Route Zero* interlude. The Sandin Image processor that appears in their game was programmed/patched by "James," according to in-game dialogue, referring to Chicago-based artist and teacher James Connolly. Connolly did, in fact, program the Sandin Image Processor for Cardboard Computer's game at SAIC. His artistic and academic work with real-time audio-video performances in new media art extends directly from the traditions we are discussing here, and is inspired by, and further expands upon, the previous work of Sandin, Morton, and their COPY-IT-RIGHT ethic.

Above
Phil Morton
General Motors, 1976
Video

Opposite
Tom DeFanti, Jane Veeder, Raul Zaritsky, Copper Giloth
Real-Time Design ZGRASS Demo, 1980
Video

Un Pueblo de Nada presents video games and video art as simultaneous and parallel paths, both vector views into different aspects of the same timespaces and stories. This simultaneity of game (as) art was also at work in Fenton's collaborative *Digital TV Dinner.* The intersections of art and games is an origin story and a context for new media, specifically in Chicago, as well as the world at large. *Digital TV Dinner* premiered publicly at the 1978 Electronic Visualization Event, or EVE 3, a public exhibition—the third in the series mentioned earlier in this text. In a later version of *Digital TV Dinner,* DeFanti explains aspects of the motivations and "aestheticconcepttechniques," a practice emphasising the symbiosis of aesthetics, concepts, and techniques: in a voice-over introduction, he recounts that this artwork "represents the absolute cheapest one can go in Home Computer Art" by "pounding" the Bally Astrocade, "popping out" the cartridge which stores the software "while it's trying to write the menu," and doing the same "pounding" to create the audio.

This description encapsulates what I refer to as "Dirty New Media Art," a concept I first proposed in 2005. As Chicago-based artist SHAWNÉ MICHAELAIN HOLLOWAY writes in her 2013 text "Venus in Glitches: Dirty New Media and Transdiscursiveness": "Dirty New Media once anticipated and now brings glitch methodologies into the territory of discreet personal actions, movements, and language."[8] As she further explains in a later text, written collaboratively with Steven R. Hammer and published by The Barber institute of Fine Arts and Vivid Projects in association with artist/curator Antonio Roberts for their 2013 Dirty New Media Art exhibition: "Dirty New Media (DNM) seeks to disengage our perception of screen-based activity from the two-dimensional, and critique material production of objects and systems."[9] In his 2016 book Glitch Art in Theory and Practice: Critical Failures and Post-Digital Aesthetics, Michael Betancourt correctly identifies that *Digital TV Dinner* involves a system interruption—removing the game cartridge while the Bally Astrocade is running—performing what HOLLOWAY and Hammer would refer to as a Dirty New Media disengagement.[10] This glitch in the cybernetic human-machine-human system critiques the systems at play, questioning our assumptions and physical materialities, i.e. of the proper functioning of electronic hardware and code-based software. Or, in more down-to-earth-terms, this experience is known to almost all children interacting with the cartridges and consoles of home video game systems of the 1970s, 80s, and 90s: when early console games glitched, we pulled cartridges out of still-running systems, blew on their exposed tin or gold-plated copper contacts, and then reinserted them repeatedly, over and over, in order to correct game glitches.

This process itself also produces glitches, as is the case with *Digital TV Dinner,* in that most rough, raw, and immediate intervention: the human pulls the plug, and the game glitches out.

In 1978, if you had pulled out a cartridge from the Bally Astrocade and read the label or diligently read the Bally Astrocade owners' manual, you would have known that the purpose of the Bally Astrocade and the Bally BASIC system was to enable people to create their "own Computer Games, Electronic Music, and Video Art," as its cover stated. It may come as no surprise, then, that Bally BASIC, the ROM-based operating system for the Bally Astrocade, was developed and project managed by Jamie Fenton for Dave Nutting Associates in 1977. Fenton saw far beyond her time, into a then-futureworld in which small-scale technologies for personal transformation, artistic creation, and exploration would bring together computer games, electronic music, and video art in the form of new media. She positioned these three forms as aspects of one available, learnable, teachable, and glitchable approach to creating cultures. In the following year, she would bring these sensibilities to the collaborative projects of BASIC ZGRASS—a "Sophisticated Graphics Language for the Bally Home Library Computer"—with DeFanti and Donato, as well as *Digital TV Dinner* with Zaritsky and Ainsworth; later, she would carry these efforts into the software development of the applications that would eventually become Adobe Director.

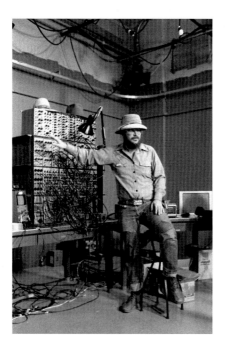

Above
Phil Morton
Video for Installation of Sandin Image Processor, 1992

Right and Below
Dan Sandin, Josephine Anstey, Geoffrey Allen Baum,
Drew Browning, Beth Cerny Patiño, Margaret
Dolinsky, Petra Gemeinboeck, Marientina Gotsis, Alex
Hill, Ya Lu Lin, Josephine Lipuma, Brenda Lopez Silva,
Todd Margolis, Keith Miller, Dave Pape, Tim Portlock,
Joseph Tremonti, Annette Barbier and Dan Neveu
EVL Alive on the Grid, 2001
Video documentation

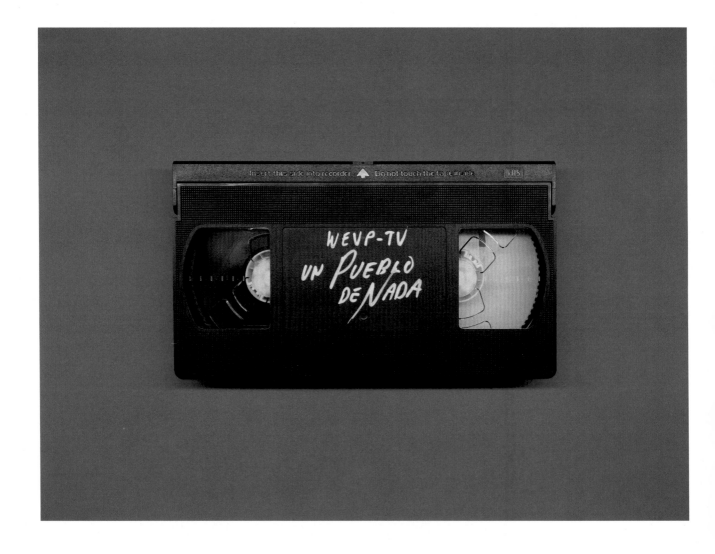

INSTITUTE of DESIGN

formerly

School of Design in Chicago ● 247 E. Ontario Street, Chicago 11, Illinois ● Telephone Delaware 4688

Fall-Winter Term 1944-45

September 25 — January 27

Day and Evening Classes

Visual Fundamentals ● Lettering
Advertising Arts
Painting ● Modeling
Occupational Therapy
Weaving
Ceramics
Architectural and Interior Design
Mechanical Drafting ● Blueprint Reading
Production Illustration ● Airbrush
Basic and Product Design ● Plastics
Photography ● Motion Pictures
Display
Life Drawing

Fees:

Full Day Term $176.50
Single Courses Day or Evening $30.00 to $50.00

Saturday Children's Class (Starts Oct. 7)

Faculty

L. Moholy-Nagy, Director

Calvin Albert, Robert Delson, Marli Ehrman, Frank Levstik, Karl Martz, James Prestini, Ralph Rapson, Else Regensteiner, Edgar Richard, Edward Rinker, Marianne Willisch, Emerson E. Woelffer.

Guest lecturers Jean Carlu, Fernand Léger, Siegfried Giedion, Frederick Kiesler, James Johnson Sweeney ● dates and subjects to be announced.

Degrees, University Credits

An eight term course leads to the degree of Bachelor of Design and Architecture.

Advanced work for qualified students leads to the degree of Master of Arts or Architecture.

Credit for work done at the Institute is allowed by Columbia, Harvard, Illinois, Michigan, Minnesota, Mills College, and Yale, and is readily arranged with other colleges and universities.

Periods of Instruction

The academic year of the Institute consists of 3 regular terms, Fall - Winter, Spring and Summer.

For illustrated catalog or further information address The Registrar.

Special Courses For Veterans

To service veterans who need a fresh approach and a broader horizon in orienting or re-training themselves for return to civilian life, the curriculum of the Institute offers a great opportunity.

Special schedules can be arranged to meet the individual veteran's needs.

The Institute will be glad to assist in arranging contracts with the Veteran's Administration.

9—44—104—7M

No refunds are given to students who leave the Institute before completion of term except in case of military service.
The Institute of Design reserves the right to make any necessary changes in the provisions of this announcement without further notice.

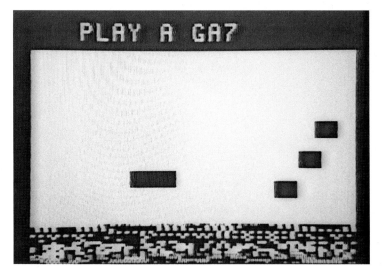

Opposite
Cardboard Computer (Jake Elliott, Tamas Kemenczy and Ben Babbitt)
Un Pueblo de Nada (Kentucky Route Zero interlude), 2018
Game

Above
Institute of Design Curriculum, 1944

Left
Bottom: Jamie Fenton, Raul Zaritsky (Video) and Dick Ainsworth
Digital TV Dinner, 1978
Video

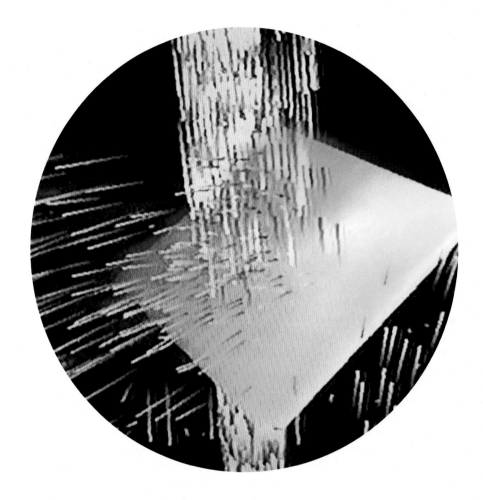

Dan Sandin, Tom DeFanti, Carolina Cruze Nevera;
with Greg Dawl (industrial design) and everyone at EVL
Detail of CAVE, 1991 – present
Installation

Anticipating

As Fenton foretold, art and games are not separate categories, but rather deeply interdependent and interrelated creative cultural activities. Culture requires dynamic, open, and compelling discourse and reinterpretation to stay vibrant. We must stay curious and playful. Playfulness is simultaneously old and forever young. In 1938, Johan Huizinga published his widely influential *Homo Ludens: A Study of the Play-Element in Culture,* the source for the field of ludology, the study of play.[11] Huizinga proposed that to play games is to be a person. You are young at heart when you are playing games because you are keeping your sense of wonder and excitement alive. You are following rules of play, instructions sets, or basic codes that create games. You are also most likely bending or breaking the rules; you are improvising in the moment, flowing with changes, and alive in the effervescent, present moment. You remain agile and flexible, open to new possibilities as they constantly unfold.

During the times and spaces addressed in this exhibition and text, games and art have fundamentally transformed—and been transformed by—computing. While arcades were once the special physical domains of games, personal computers and home gaming consoles brought digital games into intimate domestic times and spaces. These technologies changed considerably over the years, and those changes were rapid; just as digital media has become the dominant form of culture and the Internet the dominant form of communication in the West, games have become a dominant form of entertainment and an increasingly powerful cultural form of art globally. In her 2012 book *Rise of the Videogame Zinesters,* Anna Anthropy emphasizes the pervasiveness of games.[12]

During her presentation at IndieCade later that year, she stated, "Queer games are important."[13] Games, the most vital emergent cultural form today, are able to express and create experiences, and it is crucial to understand how, and for whom, they do so. Anthropy points out that these expressions and experiences are both ideological and available. Games as technologies are not neutral; like all software, games express the ideological perspectives, positions, and assumptions of those who develop them and for whom they are developed. Simultaneously, as is the case with all technologies to varying degrees, games are an art form to be coded or recoded in new ways, taken in previously unexplored directions, and/or voice various points of view. In her book *Digital Art* from 2003, Christiane Paul wrote that the new media art approach in which rules are "a process for creating art has a clear connection with the algorithms that form the basis of all software and every computer operation."[14] Games, as Anthropy has explained, are an artform of rules, rule-making, and rule-breaking. Games are systems. Digital games are computational. They are software that unfolds for us through our interactions and their interactivity. Or, as Jeffrey Daniels has said, games don't truly become art until we play them.[15]

Anthropy's work is critically successful in directly addressing queerness and transness. Sharing Anthropy's work with Fenton, I asked her if she, as a transperson and transwoman, connects with Anthropy's approach. She stated that Anthropy's work rings true for experiences that Fenton herself has found difficult to communicate outside of trans communities. Fenton has been active in trans communities while working at the highest levels of technology development, computer programming, and creative software: at

Bally/Midway in the 1970s and 1980s, founding MacroMind and joining Apple Computers in the mid-1980s, then working with Alan Kay, transitioning in the mid-1990s, and later working with Amazon and many other companies—all while pursuing her own projects. Inside the broader systems of production Anthropy is known for critiquing, Fenton has worked steadily. For example, all games made with Flash, as well as CD-ROM art and early web art authored in Director, exist as direct descendants of Fenton's contributions in both solo and collaborative work in software development. Her impact is undeniable: even now, groundbreaking artists and developers like Anthropy extend Fenton's legacy by facilitating new developments in art and games through teaching, writing, and developing and distributing of their own art and games.

Fenton developed the multimedia art/game-authoring software MacroMind VideoWorks in 1985, which became MacroMedia Director in 1987. The Director platform engendered countless intergenerational and genealogical new media art connections, enabling numerous artists to create what became known as "CD-ROM art," or more generally, "multimedia." This form of new media art production flourished during the early- and mid-1990s, assisted by the rapid popularization of the Internet through the World Wide Web; the increased ease of Internet usage via web browsers such as Mosaic and subsequent Mosaic-like browsers greatly increased the audience for new media art and set the stage for current new media art and game practices.

During the 1990s, artists worked with interactivity online via the Web and offline using multimedia authoring tools, such as

Director, for distribution on CD-ROM. Many artists creating CD-ROM-based artworks developed what media archeologist Erkki Huhtamo called "the archaeological approach in media art."[16] Huhtamo identified this tendency in a number of artworks produced with the Director authoring software; in particular, he identifies Morton's former student Christine Tamblyn and her 1993 work *She Loves It, She Loves It Not: Women and Technology.* In 1996, Huhtamo curated an exhibition of "CD-ROM art" that included Tamblyn's project; in his introduction to the exhibition he wrote that CD-ROM technology had, by the time of his writing, become a ubiquitous standard feature of personal computing and that artists were dealing with this technology in innovative ways. Part of the innovations that Huhtamo highlighted were the ways in which CD-ROM technology enabled independent artists to distribute their own work themselves. Artists were continuing to ask critical questions about the issues of distribution and access, given that the CD-ROM was designed to be an easily distributed and duplicated material form. Huhtamo also underscored the media art historical connection of this activity, writing that CD-ROM art shared "similarities with the pioneering times of video art in the 1960's and 1970's."[17] This is evident in Tamblyn's projects: through her work with Director, she and Fenton connect back through shared hystories and project us into futures that importantly support agency in self-expression. Self-publishing and independent distribution of art/games continues to be a critical aspect of the cultures and commodities of games.

Art games convey powerful stories and create deeply moving emotional experiences. They mobilize affective identification drawing us

Anna Anthropy
Triad, 2013
Game

directly into the thoughts and feelings of the characters we play. Art games involve substantial levels of involvement from the emotional experiences of gameplay to the time commitments involved in playing games. A range of time commitments exists in contemporary game cultures with some games approaching the infinite gameplay. The seemingly limitless durations of endless gameplay for games that, for instance, rely on procedural generation, open worlds or which have profound replayability, can be found in a spectrum of games from the major entertainment products of AAA games to casual games, and/or indie games to art games. The cultural category of art games has grown over the years with notable early works breaking ground for the field. Natalie Bookchin's 1998 project, *The Intruder*, is one such work of art; it is an art game that directly addresses the patriarchy while referencing and analyzing the power of video games. Authored in Director, thereby connecting this work to that of Jamie Fenton, *The Intruder* operates on many levels as a critical form of play mobilizing feminist perspectives. Exported and published online as a Shockwave game, *The Intruder* was formally at home alongside the crush of Shockwave games populating the Internet in the late 90s and early 2000s. Almost twenty years ago, Bookchin identified the importance of combining art and games online, as the Internet granted artists access to new audiences. In a 2000 interview with *The New York Times*, she claimed that the unprecedented exposure afforded by the Internet made it the "most important medium of our time."[18]

Art games are foundational to new media art. From the camera obscura to CAVE Technologies, these types of systems offer a complex combination of simulation and control, guiding or prompting the creation of individual experiences. In our exhibition, these experiences are presented in myriad different ways: Nancy Bechtol takes us inside the American Indian Center in Chicago, then digitally processes her view through a cyberpsychedelic lens; in the EVL CAVE we are awash in the spiralling perspectives of particles raining in real time; and Jason Salavon's *Everything, All at Once (Part III)* creates McLuhanesque simultaneity and all-at-once-ness by creatively coding new tools that give shape to new forms of art. This work enables us to directly (re)shape ourselves and how we (re)vision our worlds.

As *Jean Baudrillard* wrote in *On Seduction,* this complex of combination affects and illusions does "not attempt to confuse itself with the real" but rather, "...fully aware of play and artifice, it produces a simulacrum by mimicking ... and release from the real is achieved by the very excess of its appearances."[19] This is the enchanted simulation of art and games at the intersections of these technosocial systems, a genealogy that continues from ~ 470 BC, when 墨子 (Mozi) developed the science of optics, to the most recent experiments in virtual reality. We go to these spaces together to share these experiences. We agree to play games together, following (or bending) the rules, sharing the creative experiences of worldbuilding and storytelling. As has been noted from Huizinga on, you can call the space in which game play takes place by different names; however, we create it together, and it is special. Even as games permeate our daily routines and everyday actions, we integrate game experiences into our lives while still recognizing that they are particular, and purposeful.

Some of the stories that make up the hystories of Chicago New Media have become well known across the world, some only regionally. Still others are little known or recognized. This writing, the exhibition, and its events bring a number of these stories together without attempting to be definitive or exhaustive. Like staring at a wide open Midwestern night sky, out beyond the city limits, we are looking together at constellations of living and dead stars, artificial satellites, the paths of planes, and the orbits of planets. You will make your own associations, we hope, drawing your own connections and conclusions. This is how I grew up, in the Midwest, running through the rural grasslands and staring at the horizon lines. This is why I love *Translator II: Grower* by Sabrina Raaf, a responsive robot making drawings of grass in the gallery/museum space. In our exhibition, Raaf's robot runs, writing its grass on the walls alongside artworks written in (Defanti's) GRASS and (DeFanti, Fenton and Donato's) ZGRASS computer programming languages. And this is how I hope you feel: uneasy, on the edge of something, like standing in a field, watching Siebren Versteeg's post-9/11 work *Emergency* being computed and rendered in real time on the edge of prairie. When we encounter art, we often consider the experience to be constitutive of the imaginative or aspirational space of human potential and possibilities. We are here in a special time and place, connecting categories and communities of intention and imagination which have been formed and anticipated by so many collaborative contributions over the decades. These connections and associations, across times and spaces, represent creative communities of coding in the Midwest. Brought together in this exhibition, art and games are Chicago New Media.

Dan Sandin, Tom DeFanti, Carolina Cruze Nevera;
with Greg Dawl (industrial design) and everyone at EVL
CAVE, 1991 – present
Installation

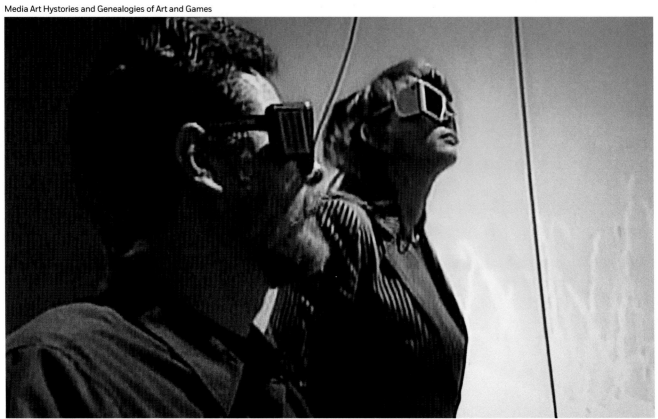

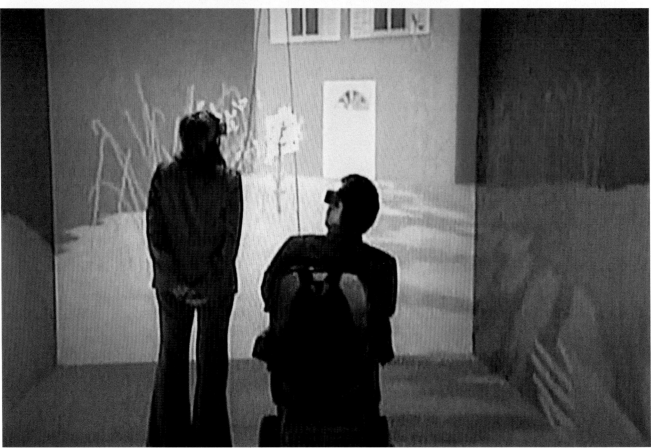

Notes

1 New Media Futures: The Rise of Women in the Digital Arts, eds. Donna Cox, Ellen Sandor, and Janine Fron (Urbana-Champaign: University of Illinois Press, 2018).

2 Theodor Nelson, Computer Lib: You Can and Must Understand Computers Now; Dream Machines: New Freedoms Through Computer Screens — A Minority Report (Self-published, 1974).

3 "Jane Veeder Interviewed by criticalartware," criticalartware (2003), *http://criticalartware.net.*

4 Dwight D. Eisenhower, "Farewell Radio and Television Address to the American People," January 17, 1961.

5 Fred Turner, From Counterculture to Cyberculture: Stewart Brand, The Whole Earth Network, and the Rise of the Digital Utopianism (Chicago: University of Chicago Press, 2006).

6 In 2007 I initiated the Phil Morton Memorial Research Archive in the Film, Video, Media and Animation department at SAIC to archive and distribute the art and research of Phil Morton. The archive was made possible through generous donations from Morton's partner, the late Barb Abramo. Phil Morton's General Motors (1976) can be viewed and downloaded in its entirety through the Phil Morton Video Archive Vimeo account, *https://vimeo. com/23027721.*

7 Jake Elliott, "Dirty New Media: Art Activism and Computer Counter Cultures," 2008, HOPE, the Hackers on Planet Earth conference DVD, 2600 — The Hacker Quarterly.

8 SHAWNÉ MICHAELAIN HOLLOWAY, "Venus in Glitches: Dirty New Media and Transdiscursiveness," In Media Res: A MediaCommons Project, February 6, 2013, *http://mediacommons.futureofthebook. org/imr/2013/02/06/venus-glitches-dirty-new-media-and-transdiscursiveness.*

9 Steven Hammer and SHAWNÉ MICHAELAIN HOLLOWAY, "1_approach. dnm: (inter)active viewership in dirty new media," 2013, *http://gl1tch.us/ DNMw3rkstati0n.txt.*

10 Michael Betancourt, Glitch Art in Theory and Practice: Critical Failures and Post-Digital Aesthetics (London: Routledge, 2016).

11 Johan Huizinga, Homo Ludens: A Study of the Play-Element in Culture (London: Routledge, 1949).

12 Anna Anthropy, Rise of the Videogame Zinesters: How Freaks, Normals, Amateurs, Artists, Dreamers, Drop-outs, Queers, Housewives, and People Like You Are Taking Back an Art Form (date).

13 Anthropy, presentation at IndieCade: International Festival of Independent Games, Los Angeles, October 11-13, 2012.

14 Christiane Paul, Digital Art (2003), 11.

15 Sierra Nicole Rhoden, "Artists at Play: Jeffrey Daniels' Social Games," The Chicago Arts Archive: A Sixty Inches From Center Project, June 4, 2012, *http://sixtyinches-fromcenter.org/archive/?p=15712.*

16 Erkki Huhtamo, "Resurrecting the Technological Past: An Introduction to the Archeology of Media Art," InterCommunication 14 (1995).

17 Ibid.

18 "On This Network, Nothing but Internet Art," The New York Times, February 10, 2000.

19 Jean Baudrillard, Selected Writings, ed. M. Poster (Cambridge: Polity Press, 1996), 156.

Opposite
Drew Browning and Annette Barbier, programming and VRML-CAVE conversion Geoffrey Allen Baum Home, 2000-2001
Installation

Phil Morton
Ars Electronica, 1992
Video for Installation of Sandin Image Processor

Chicago New Media

1973–1992

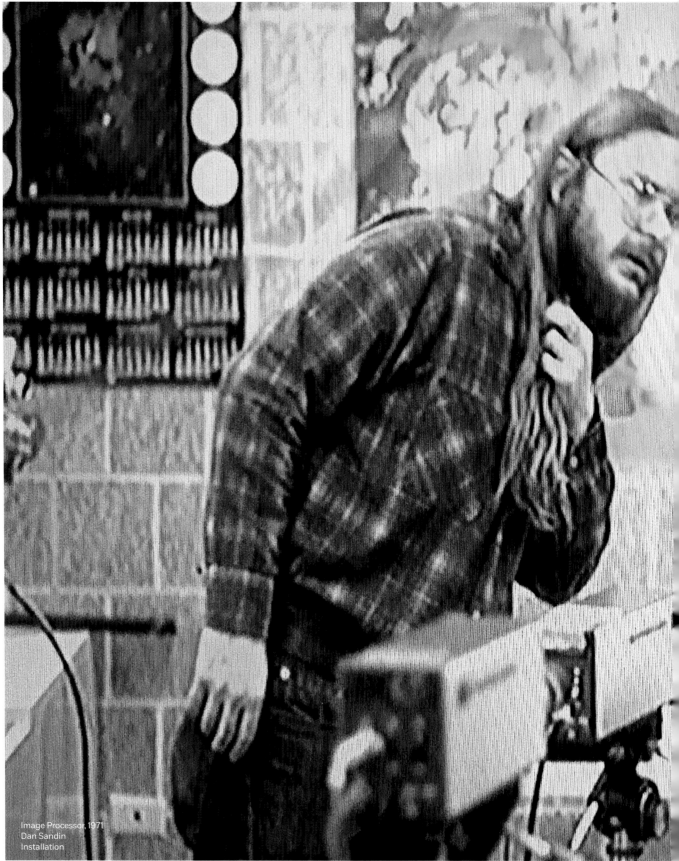

Image Processor, 1971
Dan Sandin
Installation

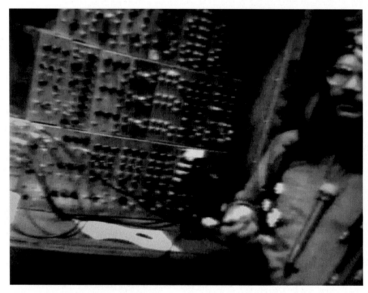

Dan Sandin
Five-minute Romp through the IP, 1973
Video

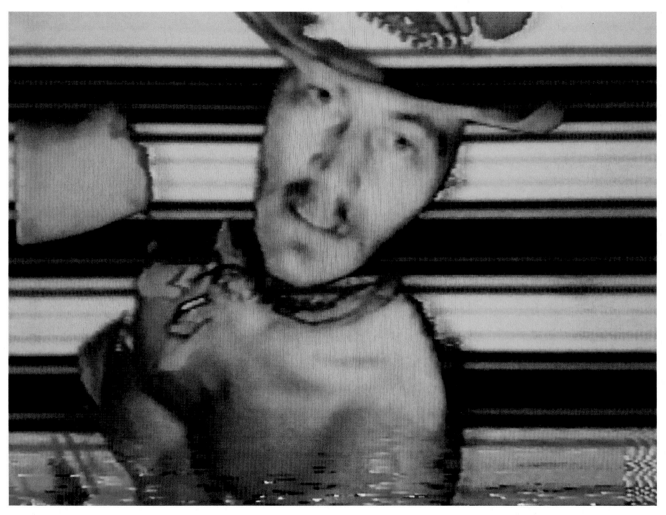

Phil Morton
General Motors, 1976
Video

Annette Barbier and Richard Mandeberg
Speak to Me Softly, 1977
Video

Jamie Fenton and Raul Zaritsky (Video) and Dick Ainsworth (Audio)
Digital TV Dinner, 1978
Video

Phil Morton and Chip Dodsworth (Video) and Barry Brosch (Audio)
Cetacean, 1978
Video

Tom DeFanti, Phil Morton, Dan Sandin and Jane Veeder (Video), Sticks Raboin and Bob Snyder (Audio) and Rylin Harris (Dance)
Spiral 3, 1978
Video

Phil Morton and Guenther Tetz (Video), Leif Brush and Stu Pettigrew (Audio)
Wire Trees with 4 Vectors, 1978
Video

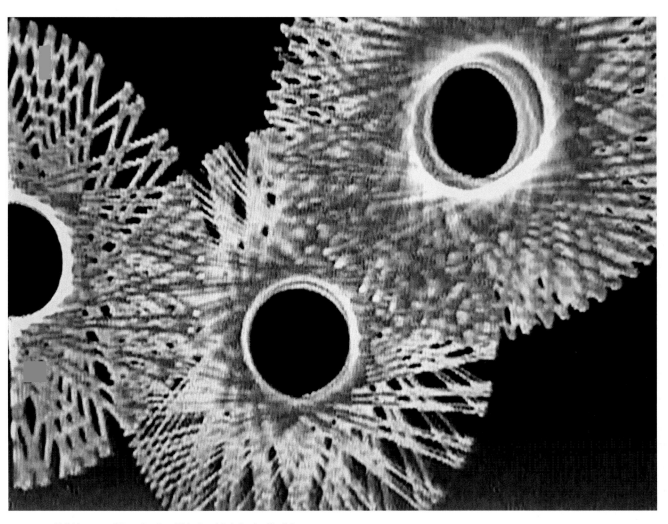

Phil Morton and Guenther Tetz (Video) and Bob Snyder (Audio)
Data Bursts in 3 Moves, 1978
Video

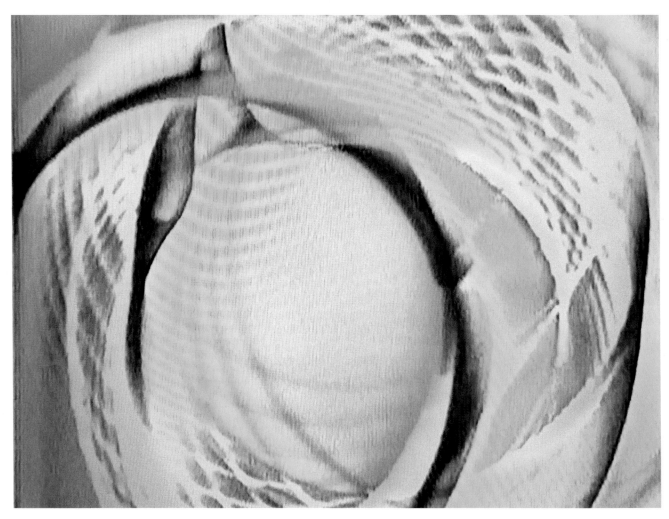

Tom DeFanti and Barbara Sykes (Video), Glen Charvat, Doug Lofstrom, Rick Panzer and Jim Teister (Audio)
By the Crimson Bands of Cyttorak, 1978
Video

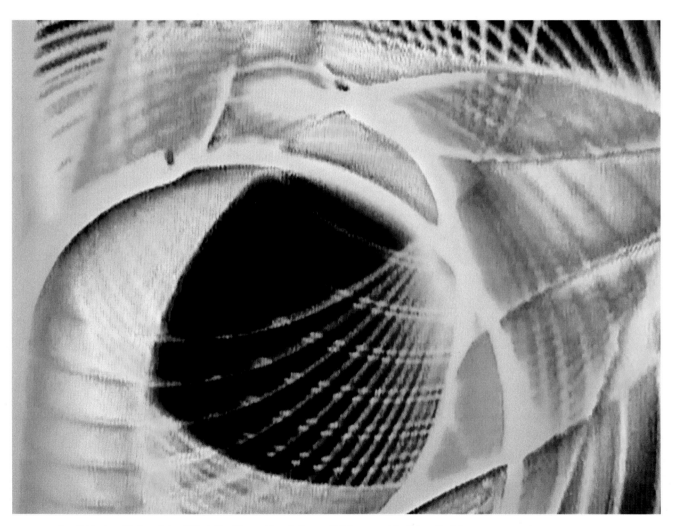

Tom DeFanti and Barbara Sykes (Video), Glen Charvat, Doug Lofstrom, Rick Panzer and Jim Teister (Audio)
By the Crimson Bands of Cyttorak, 1978
Video

Dan Sandin
The Digital Image Colorizer, 1979
Video documentation

Dan Sandin
Wandawega Waters, 1979
Video

Dan Sandin, Tom DeFanti and Mimi Shevitz
Spiral 5 PTL (Perhaps The Last), 1979
Video

Dan Sandin, Tom DeFanti and Mimi Shevitz
Spiral 5 PTL (Perhaps The Last), 1979
Video

Jane Veeder
Montana, 1982
Video

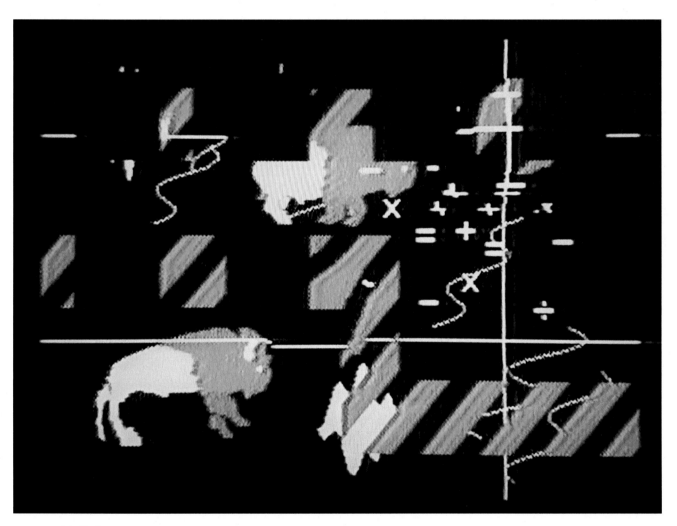

Jane Veeder
Floater (The Final Sequence), 1982
Video

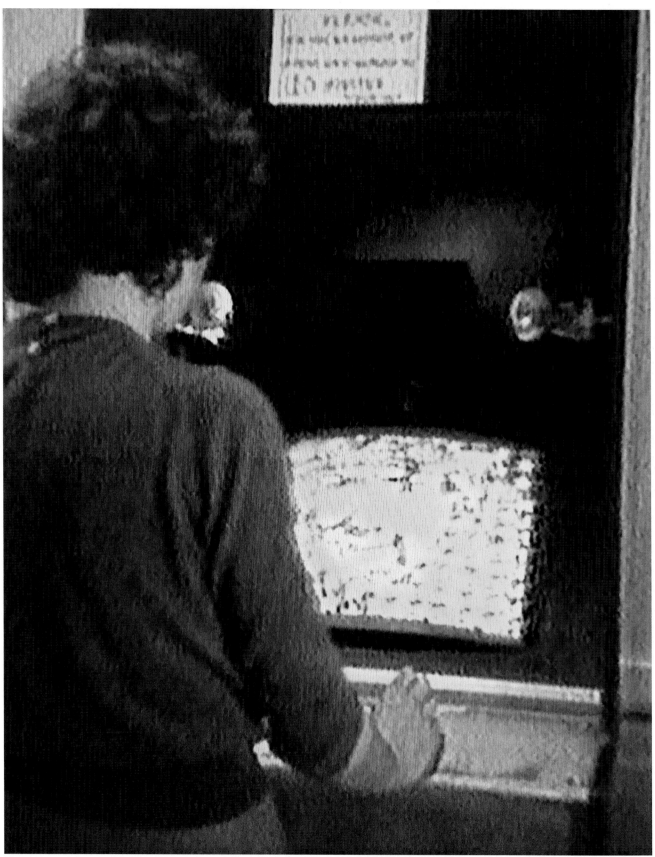

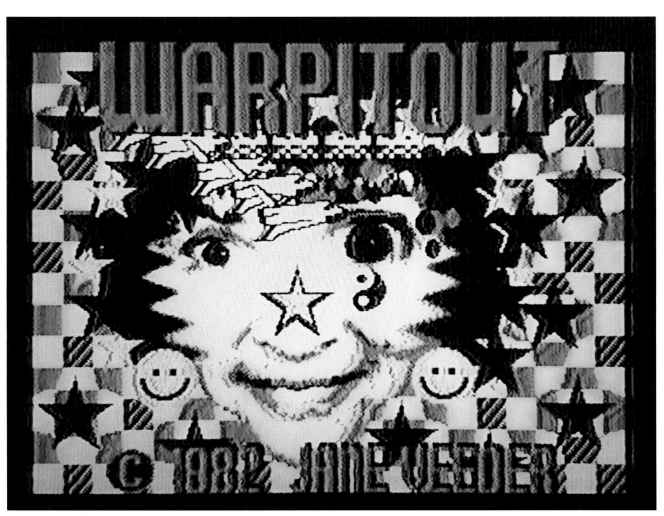

Opposite and This Page
Jane Veeder
Warpitout, 1982
Video documentation

View of a Generative Systems classroom, School of the Art
Institute of Chicago, c. 1976.
1 slide: col.; 35 mm. Unknown photographer. The Daniel
Langlois Foundation for Art, Science, and Technology,
Sonia Landy Sheridan fonds.
Courtesy of the Daniel Langlois Foundation.

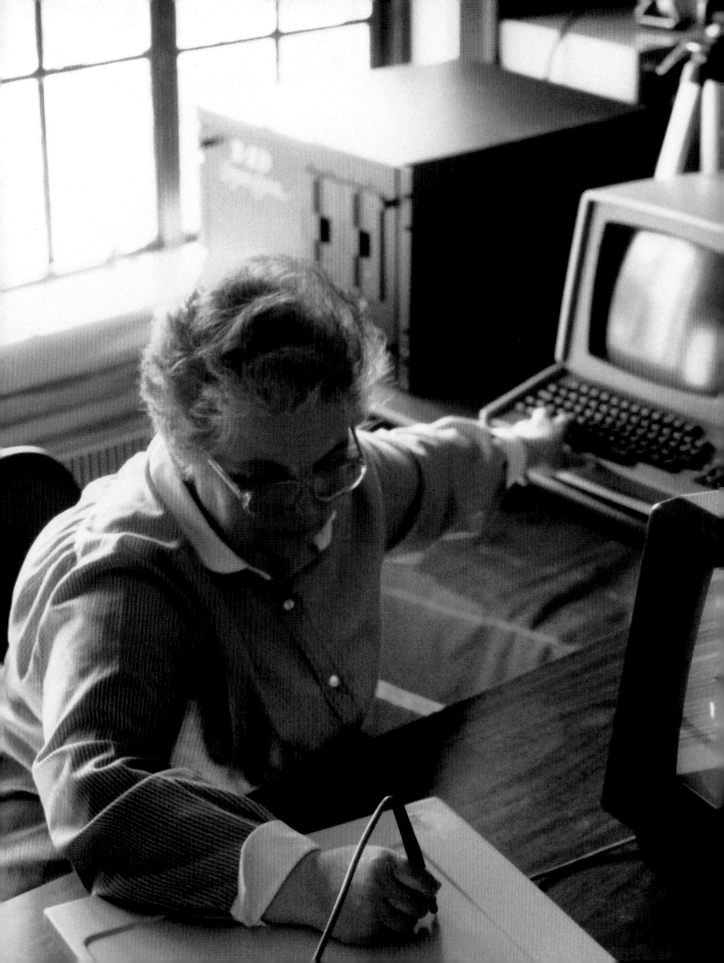

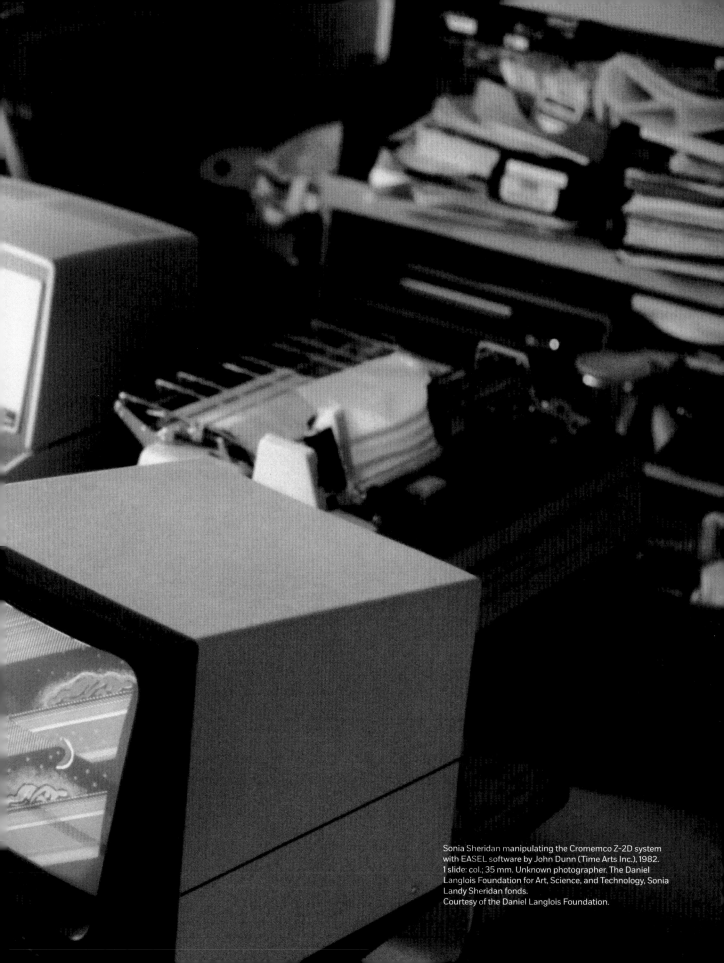

Sonia Sheridan manipulating the Cromemco Z-2D system
with EASEL software by John Dunn (Time Arts Inc.), 1982.
1 slide: col.; 35 mm. Unknown photographer. The Daniel
Langlois Foundation for Art, Science, and Technology, Sonia
Landy Sheridan fonds.
Courtesy of the Daniel Langlois Foundation.

Tom DeFanti and everyone from Electronic Visualization Laboratory
The Interactive Image, 1987
Video documentation

Tom DeFanti and everyone from Electronic Visualization Laboratory
The Interactive Image, 1987
Video documentation

Dan Sandin (Computer graphics and RT/1 programming), Laurie Speigel and Laurie Lou
Kauffman (Original music and audio effects), and Tom DeFanti (Visual leadership)
A Volume of 2-Dimensional Julia Sets, 1990
Video

Ellen Sandor, Stephan Meyers, Janine Fron and Craig Ahmer, (art)n
(Collaborative Artists: John Hart; Special thanks: Dan Sandin and Tom DeFanti
and the Electronic Visualization Lab)
Fractal Forest, 1991
PHSCologram

Tom DeFanti, Jane Veeder, Raul Zaritsky, Copper Giloth
Real-Time Design ZGRASS Demo. 1980
Video

Phil Morton
Ars Electronica, 1992
Video for Installation of Sandin Image Processor

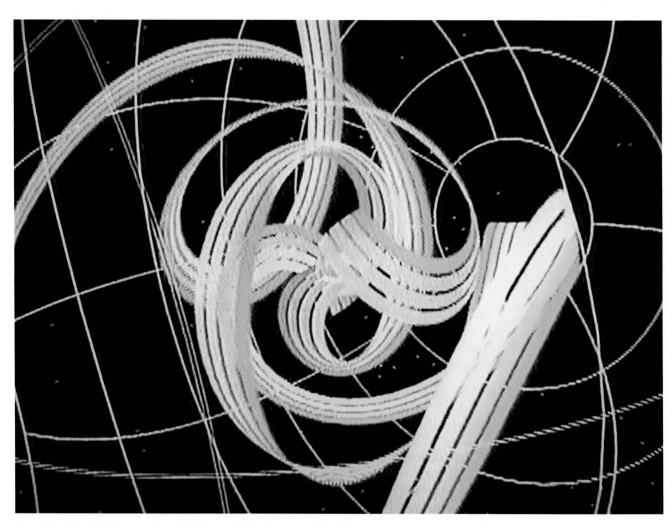

George Francis, Louis Kauffman and Dan Sandin (Concept), Chris Hartman and John Hart
(Computer graphics), Jan Heyn Cubacub (Dance), Dana Plepys (Editor) and Sumit Das (Music)
Air on the Dirac Strings, 1993
Video

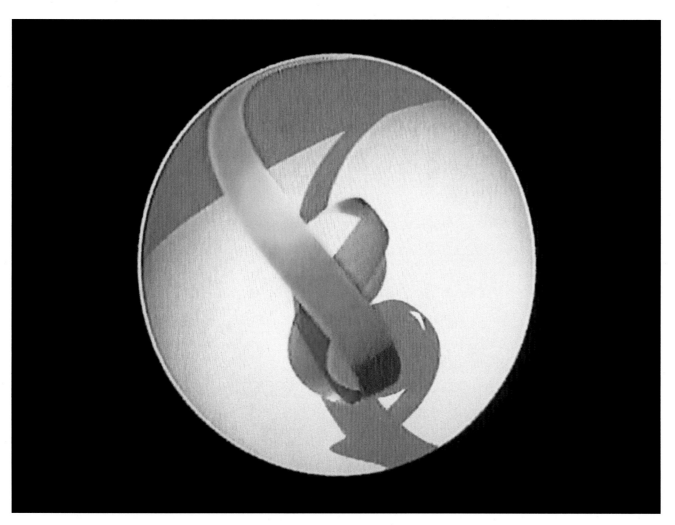

George Francis, Louis Kauffman and Dan Sandin (Concept), Chris Hartman and John Hart
(Computer graphics), Jan Heyn Cubacub (Dance), Dana Plepys (Editor) and Sumit Das (Music)
Air on the Dirac Strings, 1993
Video

to the writer's temptation of emphasizing or adding certain
details.

People say (but this is unlikely) that the story was first told
by Eduardo, the younger of the Nelsons, at the wake of his
elder brother Cristián, who died in his sleep sometime back in
the nineties out in the district of Morón. The fact is that
someone got it from someone else during the course of that
drawn-out and now dim night, between one sip of maté and
the next, and told it to Santiago Dabove, from whom I heard
it. Years later, in Turdera, where the story had taken place, I
heard it again. The second and more elaborate version closely
followed the one Santiago told, with the usual minor varia-
tions and discrepancies. I set down the story now because I
see in it, if I'm not mistaken, a brief and tragic mirror of the
character of those hard-bitten men li... the edge of Bue-
nos Aires before the turn of the c... pe to do this in
a straightforward way, but I see i... r I shall give in
to the writer's temptation of e... dding certain
details.

People say (but this is unlikely) ... was first told
by Eduardo, the younger of the N... the wake of his

Natalie Bookchin
Still from The Intruder, 1998

Dan Sandin (Virtual environment), Laurie Spiegel (Sound), Dick Ainsworth (Kayaking partner)
and Tom DeFanti (Electronic Visualization partner)
From Death's Door to the Garden Peninsula, 1999
Video

Sabrina Raaf
Translator II: Grower, 2004
Installation

Dan Sandin
Looking for Water, 2001 - 2005
Video

Nick Briz
Apple Computers, 2013
Video

Nancy Bechtol
Native Dance Vibrations, 2007
Video

Sara Ludy
Sky Canyon, 2018
Video

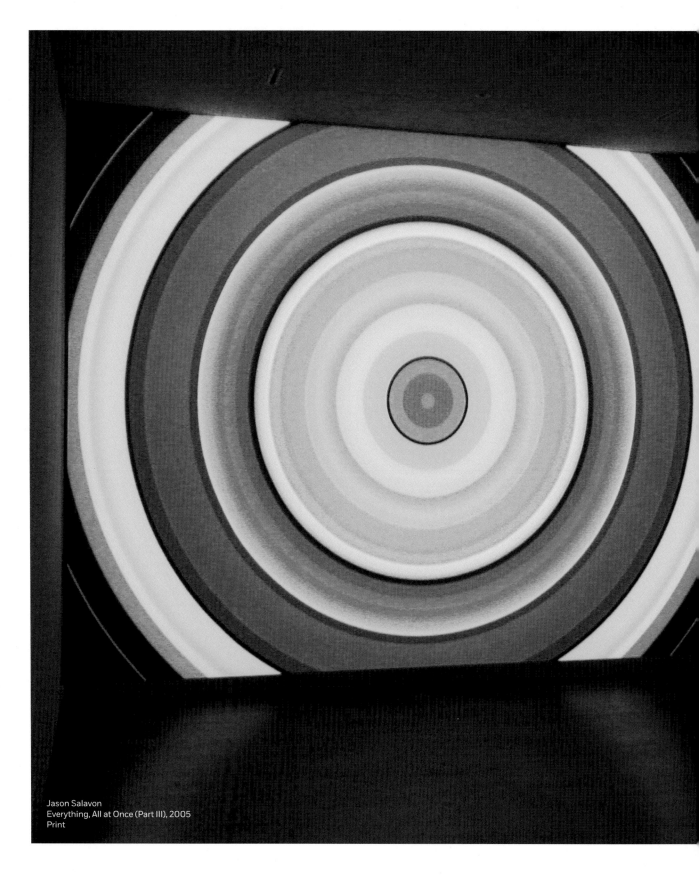

Jason Salavon
Everything, All at Once (Part III), 2005
Print

Ellen Sandor, Chris Kemp, Diana Torres, and Azadeh Gholizadeh, (art)n (Special thanks: Janine Fron; Code: William Robertson; Narration: Rachel Bronson, Bulletin of the Atomic Scientists)
Have a Nice Day II: VR Tour Through the Decades, 2017. In Memory of Martyl, 2017
VR (Unity for Oculus Rift)

Sara Ludy
OTHA, 2011
Video

☑ Joy Keys ?

Jeffrey Daniels
Lift, 2018

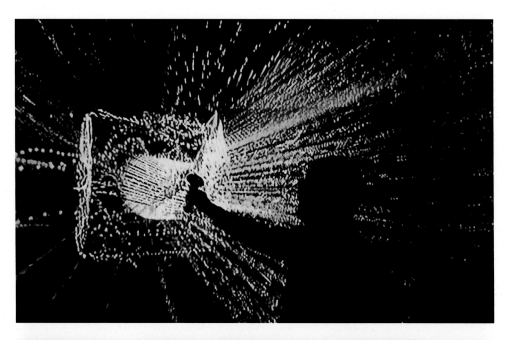

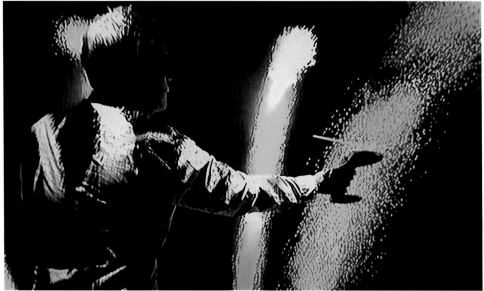

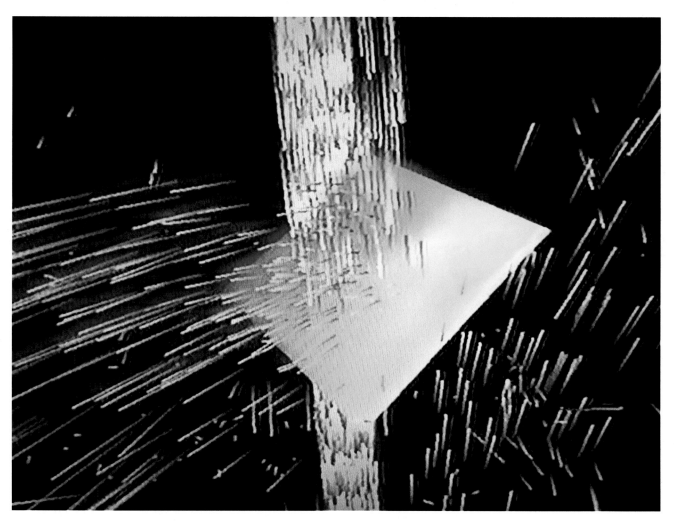

Dan Sandin, Tom DeFanti, Carolina Cruze Nevera; with Greg Dawl (industrial design) and everyone at EVL
CAVE
1991 – present
Installation

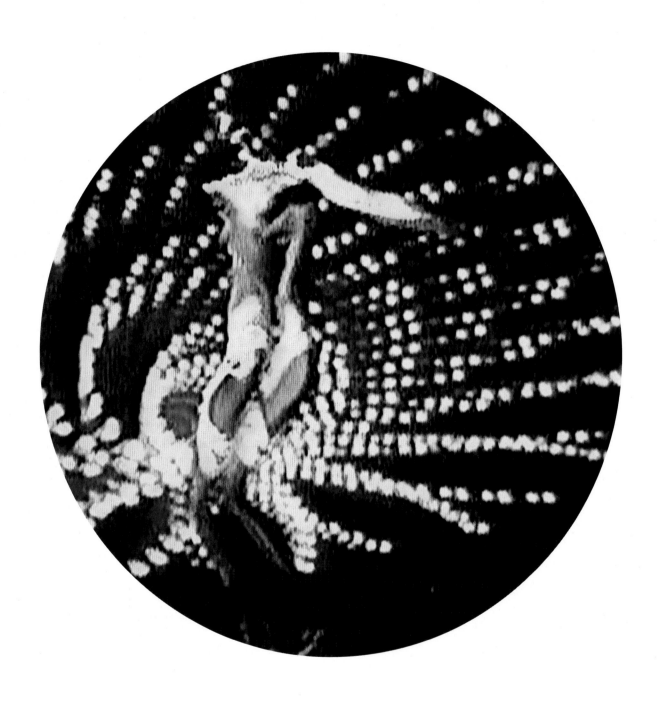

Tom DeFanti, Phil Morton, Dan Sandin and Jane Veeder
(Video), Sticks Raboin and Bob Snyder (Audio) and Rylin
Harris (Dance)
Spiral 3, 1978
Video

Networks (A Rhizomatic Timeline)
jonCates (2018)

~ 470 BC – 391 BC 墨子 (Mozi) develops optics including what will become known as the camera obscura in the location of present-day People's Republic of China

~ 801 – 873 وبأ فـسـوي بـن إسـحاق الصـبـاح الكندي (Abu Yūsuf Ya'qūb ibn 'Isḥāq aṣ-Ṣabbāḥ al-Kindī) develops optics including what will become known as the camera obscura in the location of present-day Iraq

~ 965 – 1040 وبأ علـي، الـحسن بـن الـحسن بـن الـهيثم (Abū ʿAlī al-Ḥasan ibn al-Ḥasan ibn al-Haytham) develops optics including what will become known as the camera obscura in the location of present-day Iraq

1031–1095 沈括 (English: Shen Kuo or Shen Gua) develops optics including what will become known as the camera obscura in the location of present-day People's Republic of China

1744 Baseball is documented as a game in the United Kingdom

1856 Baseball becomes known as the national game of the United States of America

1882 The Chronophotographic Gun, Étienne-Jules Marey

1910 Essanay Film Studio; Broncho Billy silent western film

1911 Marshall McLuhan born

1915 Essanay Studio; Charlie Chaplin film His New Job

1917 Fountain, R. Mutt (Marcel Duchamp)

1918 Exquisite Corpse, Surrealist Games, the Surrealists (~1918 – ~1925)

1925 John Logie Baird develops the first electro-mechanical television broadcast system

1927 Philo Farnsworth develops the first fully-electronic television technology, including television video camera tube

1934 Fernsehsender "Paul Nipkow," the first television station, begins public broadcasts in Berlin, during the Dritten Reich (Third Reich) of Nazi Germany, primarily consisting of live transmissions

1938 Stewart Brand born

1938 DuMont Laboratories manufactures, markets, and sells c ommercial television sets

1938 Konrad Zuse develops the Z3 computer

1938 IIT Curriculum and Admissions booklet, produced by the School of Design, Illinois Institute of Technology (IIT)

1938 Documentation photos of Laszlo Moholy-Nagy, IIT School of Design's Dearborn, Prairie, and Ontario buildings and classes, design exhibitions, and booklets

1938 In Homo Ludens: A Study of the Play-Element in Culture, Johan Huizinga

1940 Radiation Laboratory, Massachusetts Institute of Technology (MIT) with National Defense Research Committee (NDRC) founded (1940 - 1945); Office of Scientific Research and Development (OSRD) founded

1942 Dan Sandin born

1942 Gene Youngblood born

1943 Williams Manufacturing Company founded by Harry Williams

1943 Barb Abramo born

1944 Jane Veeder born

1945 Phil Morton born

1945 "As We May Think," Vannevar Bush

1945 Project RAND created under special contract to the Douglas Aircraft Company by founders including H. H. "Hap" Arnold, Secretary of War, Commanding General of the Army Air Force; Major General Curtis LeMay; General Lauris Norstad, Assistant Chief of Air Staff, Plans;

Edward Bowles of the Massachusetts Institute of Technology (MIT), consultant to the Secretary of War; Donald Douglas, president of the Douglas Aircraft Company; Arthur Raymond, chief engineer at Douglas; and Franklin Collbohm, Raymond's assistant (1945 - 1952)

1945 Project WHIRLWIND developed at MIT by Stephen Dodd; Jay Forrester; Robert Everett; Ramona Ferenz; the United States Navy; the University of Illinois; Harry Nyquist of Bell Laboratories; Lieutenant General Leslie Richard Groves, Jr. of the United States Army Corps of Engineers, the Department of Defense, The Pentagon, and the Manhattan Project; The Canadian Airforce; the British Airforce, Francis Wheeler Loomis of University of Illinois; the Defense Systems Engineering Committee; the United States Army Signal Corps; Western Electric; Douglas Corporation; the United States Air Force, the Army Anti-Aircraft Command (ARAACOM)/US Army Air Defense Command (USARADCOM)/ ARADCOM; Heinrich Ernst Albers-Schönberg; Nathaniel McLean Sage (1945 - 1952)

1946 Ted Nelson identifies 1946 as the date of "the first computer" in his book The Home Computer Revolution

1946 Preliminary Design of an Experimental World-Circling Spaceship, Project RAND

1947 Harry S. Truman signed the National Security Act of 1947 founding the "National Military Establishment," creating the Central Intelligence Agency (CIA), the National Security Council, National Security Resources Board, United States Air Force (formerly the Army Air Forces) and the Joint Chiefs of Staff.

1948 RAND Corporation (previously Project RAND) reformed as a private organization by the The United States Department of War and the Office of Scientific Research and Development; RAND Corporation is then incorporated as a nonprofit in Santa Monica California with involvement by L. J. Henderson, Jr. and RAND's original Board of Trustees: Charles Dollard, president, Carnegie Corporation of New York; Lee A. Dubridge, president, California Institute of Technology; John A. Hutcheson, director, research laboratories, Westinghouse Electric Corporation; Alfred L. Loomis, scientist; Philip M. Morse, physicist, Massachusetts Institute of Technology (MIT); Frederick F. Stephan, professor of social statistics and director, Office of Survey Research and Statistics, Princeton University; George D. Stoddard, president, University of Illinois; Clyde Williams, director, Battelle Memorial Institute; then the Ford Foundation.

1948 IIT Academic Catalog

1949 The National Military Establishment renamed the "Department of Defense" (DoD)

1950 Lucky Inning pinball game, Williams Electronics

1951 Christine Tamblyn born

1951 The Mechanical Bride: Folklore of Industrial Man, Marshall McLuhan (1951)

1951 Semiautomatic Ground Environment Air Defense System (SAGE) developed at MIT with United States Air Force (USAF); United States Navy; USAF Air Material Command; Western Electric; System Development Corporation; Burroughs Corporation; IBM Military Products Division; Project WHIRLWIND (1951 - 1984, operational from 1958 - 1966)

1951 Lincoln Laboratory, Massachusetts Institute of Technology (MIT) with United States Air Force (USAF) created (1951 - present)

1951 St. Louis Dispatch articles "New Approach to Design" and "Institute Combines Art and Technology" about IIT Curriculum are published

1955 Resistance War Against America/The Vietnam War in Vietnam, Laos, and Cambodia (1955 - 1975)

1957 Sputnik 1, The Union of Soviet Socialist Republics' space program

1958 The National Aeronautics and Space Administration (NASA) established

1958 Williams Electronic Manufacturing Company, formerly Williams Manufacturing Company, renamed

1959 - 1969 Douglas Engelbart develops The Stanford Research Institute's Augmentation Research Center (SRI's ARC). ARC is funded by the Air Force Office of Scientific Research (in 1959), the US Defense Department's Advanced Research Project Agency (DARPA in 1963), and NASA (in 1964)

1959 FLUXUS (~1959 - 1978)

1959 PDP-1 (Programmed Data Processor-1), Digital Equipment Corporation (DEC)

1960 PLATO, University of Illinois

1960 Man-Computer Symbiosis, J.C.R. Licklider

1961 "Eisenhower's farewell address to the nation," President Dwight D. Eisenhower

1961 The Union of Soviet Socialist Republics' space program succeeds in launching the first person, Юрий Алексеевич Гагарин (Yuri Alekseyevich Gagarin), into outer space to travel in a low Earth orbit and return safely to the surface of the Earth

1961 Freedom Rides, Congress of Racial Equality (CORE)

1962 Spacewar!, Stephen Russell, Martin Graetz, Wayne Wiitanen, Peter Samson, Dan Edwards, with Alan Kotok, Steve Piner, and Robert A Saunders at MIT using PDP-1 assembly language

1962 The Gutenberg Galaxy: The Making of Typographic Man, Marshall McLuhan

1962 The first transatlantic satellite television transmission via Telstar satellite

1962 Instruction Pieces, Yoko Ono

1963 "Sketchpad: A Man-machine Graphical Communications System," Ivan E. Sutherland

1963 The RAND Tablet: A Machine Graphical Communication Device, RAND Corporation

1963 Simulation of a Two-Gyro, Gravity-Gradient Attitude Control System, Edward E. Zajac

1963 Marshall McLuhan's Centre for Culture and Technology opens at The University of Toronto

1963 John Fitzgerald Kennedy, the 35th President of the United States, assassinated on camera

1963 Random Access, Nam June Paik

1964 Understanding Media: The Extensions of Man, Marshall McLuhan

1964 GRAIL, RAND Corporation

1964 IBM 360 M42 Mainframe Digital Computer with 2250 Graphic Display

1964 The Merry Pranksters founded; later Ken Kesey and The Merry Pranksters begin the Magic Bus trip

1965 Malcolm X, spiritual and political leader for racial justice, assassinated

1965 "The Ultimate Display," Ivan E. Sutherland

1965 Alan Kay reads Gordon Moore's Law

1965 Acid Tests, Ken Kesey, the Merry Pranksters, and The Warlocks, later known as The Grateful Dead (1965 - 1966)

1965 Psychedelic liquid light shows performed by Bill Ham in San Francisco at The Fillmore

1965 Magnet TV, Nam June Paik

1966 The Cultural Revolution, The People's Republic of China

1966 Black Panther Party founded by Bobby Seale and Huey Newton

1966 The Trips Festival with performances by The Grateful Dead, Stewart Brand, Ramon Sender, Ken Kesey, the Merry Pranksters, and Bill Graham

1966 Dr. Timothy Leary announces the formation of the League for Spiritual Discovery stating: "Turn on, tune in, drop out"

1966 Alan Kay reads Ivan E. Sutherland's "Sketchpad: A Man-machine Graphical Communications System"

1966 Play it by Trust (All White Chess Set), Yoko Ono

1966 PDP-10 - Digital Equipment Corporation (DEC)

1967 Shangri-La pinball game, Williams Electronics

1967 "Paragraphs on Conceptual Art," Sol Lewitt

1967 SONY "Video Rover" DV-2400 Portapack, SONY Corporation

1967 The Summer of Love

1967 Society of the Spectacle, Guy Debord (1967 - 1973)

1967 Hummingbird, Charles Csuri

1967 Douglas Engelbart visits University of Utah and presents his oN-Line System (NLS); Alan Kay attends the presentation as a student

1967 The Medium is the Massage: An Inventory of Effects, Marshall McLuhan, Quentin Fiore, and Jerome Agel

1967 Sound?? starring Rashaan Roland Kirk and John Cage, directed by Dick Fontaine

1967 Applications Technology Satellite 3 (ATS-3) satellite photographs the Earth from space, Hughes Aircraft Company and NASA

1967 "Multiple Computer Networks and Intercomputer Communications," Dr. Lawrence G. Roberts

1967 Sam Matsa (IBM/GM and ACM Board member) and Andy Van Dam (Brown University) organize a series of seminars on Interactive Computer Graphics that would become the basis of the Special Interest Group on Computer GRAPHics and Interactive Techniques (SIGGRAPH)

1968 Dr. Martin Luther King Jr., spiritual and political leader for racial justice, assassinated

1968 Robert Francis "Bobby" Kennedy, United States Senator from New York, assassinated

1968 The Mother of All Demos, Douglas Engelbart/Stanford Research Institute

1968 Alan Kay conceptualizes, models, and prototypes the Dynabook personal computer in cardboard

1968 "The Computer as a Communication Device," J. C. R. Licklider and Robert W. Taylor

1968 Cybernetic Serendipity: The Computer and the Arts exhibition, curated by Jasia Reichardt, premieres at London Institute of Contemporary Arts

1968 War and Peace in the Global Village, Marshall McLuhan, Quentin Fiore, and Jerome Agel

1968 ATS-3 satellite photograph of the Earth becomes the cover image of the first edition of the Whole Earth Catalog

1968 The Whole Earth Catalog (WEC), Stewart Brand (1968 - 1972)

1968 Earthrise, William Anders/Apollo 8

1968 Intermedia '68: A Festival for New York State, Charlotte Moorman, Nam June Paik, Les Levine, Carolee Schneemann, Terry Riley, Dick Higgins, Ken Dewey, USCO, Aldo Tambellini, and others

1968 Ant Farm founded, Chip Lord and Doug Michels

1968 General strikes, public protests and occupations of universities and factories in Paris and across France

1968 The Prague Spring

1968 The United States Democratic Convention in Chicago

1968 American Indian Movement (AIM) founded

1969 Fred Hampton, Deputy Chairman of the Illinois chapter of the Black Panther Party, assassinated

1969 Mark Clark, Peoria Defense Captain of the Black Panther Party, assassinated

1969 ARPANET, Advanced Research Projects Agency (ARPA), RAND Corporation, University of California Los Angeles (UCLA), the University of California Santa Barbara (UCSB), the University of Utah, and the Stanford Research Institute (SRI) at Stanford University (1969 - 1977)

1969 Phil Morton joins the Faculty at The School of the Art Institute of Chicago (SAIC)

1969 Dan Sandin joins the Faculty at University of Illinois at Chicago (UIC), then referred to as the University of Illinois at Chicago Circle Campus.

1969 Dan Sandin and his students transmit live streams of video feeds at the UIC Art Building as documented by Diane Kirkpatrick in her Chicago: The City and Its Artists 1945 - 1978 (1969-1970)

1969 Paik-Abe Video Synthesizer, Nam June Paik and Shuya Abe

1969 SIGGRAPH: the Special Interest Group on Computer Graphics and Interactive Techniques founded and named as a Special Interest Group

1969 Videofreex founded

1969 TV as a Creative Medium, Howard Wise Gallery

1969 Stonewall Rebellion at the Stonewall Inn in New York City

1969 Days of Rage, Weathermen/Weather Underground

1969 Vector General (VG) graphics terminals introduced for digital computer systems

1970 Radical Software, Beryl Korot, Phyllis Gershuny, and The Raindance Corporation (1970 - 1974)

1970 Phil Morton founds the Video Area at SAIC

1970 Phil Morton founds the Video Data Bank (VDB) at SAIC

1970 Expanded Cinema, Gene Youngblood

1970 Sonia Landy Sheridan founds the Generative Systems Program at SAIC

1970 Violin Power, Steina (1970 / 1978 - present)

1970 PDP-11 series of digital computers - Digital Equipment Corporation (DEC)

1971 Dan Sandin begins development of the Sandin Image Processor

1971 Phil Morton and Dan Sandin develop "The Distribution Religion," the proto Open Source hardware documentation / forking codebase for the independent and individual building of copies of the Sandin Image Processor (1971 – 1973)

1971 Woody and Steina Vasulka found The Kitchen in New York City

1971 Dara Greenwald born

1972 Interactive video environment at St. Olaf College, Phil Morton and Dan Sandin

1972 Graphics Symbiosis System (GRASS) developed at Ohio State by Tom DeFanti

1972 Angela Davis jailed then acquitted and freed

1972 The Black Community Survival Conference, The Black Panther Party

1973 Tools for Conviviality, Ivan Illich

1973 Inconsecration of New Space, Phil Morton and Dan Sandin (on the Sandin Image Processor) with Jim Wiseman (on the Paik/Abbe Video Synthesizer)

1973 Tom DeFanti joins the Faculty at UIC

1973 Circle Graphics Habitat established at UIC by Dan Sandin and Tom DeFanti. Circle Graphics Habitat was renamed the Electronic Visualization Laboratory (EVL)

1973 Five-minute Romp through the IP, Dan Sandin

1973 Ted Nelson joins the Faculty at UIC

1973 jonCates, curator of Chicago New Media 1973–1992 exhibition, born

1974 GRASS (GRAphics Symbiosis System), Tom DeFanti

1974 Computer Lib: You Can and Must Understand Computers Now; Dream Machines: New Freedoms Through Computer Screens— A Minority Report, Ted Nelson

1974 Jane Veeder enters SAIC as a graduate student

1974 Bob Snyder joins the faculty at SAIC

1974 SIGGRAPH 1st Annual Conference on Computer Graphics and Interactive Techniques held in Boulder, Colorado

1974 Dan Sandin, Tom DeFanti, and Ted Nelson show the first Computer Graphics videotape presented at a SIGGRAPH conference accompanied by a paper entitled "Computer Graphics as a Way of Life"

1974 Dungeons & Dragons, Gary Gygax and Dave Arneson

1974 z-buffering developed by Ed Catmull at the University of Utah

1975 The First Interactive Electronic Visualization Event (EVE) held at UIC, Rotunda SES East, Phil Morton, Dan Sandin, Tom DeFanti, Bob Snyder

1975 An Instructional Game for 1 to many musicians, Click Nilson

1976 General Motors, Phil Morton

1976 The Second Electronic Visualization Event (EVE II) held at UIC, Rotunda SES CB, Dan Sandin, Phil Morton, Tom DeFanti, Bob Snyder, and others

1976 Kate Horsfield and Lynn Blumenthal take over operations of the Video Data Bank, moving the collection out of the Video Area into the Library of SAIC, creating the basis for its present international organization

1976 Bob Snyder become head of the Sound Area, which would later become the Sound Department at SAIC

1976 Phil Morton and Jane Veeder meet in the Spring of 1976 in Chicago's Pilsen neighborhood

1976 Colossal Cave Adventure, William Crowther

1976 Computers: Challenging Men's Supremacy, Hobel-Leiterman Productions

1976 Electric Pencil, Michael Shrayer

1976 The Bally Fireball Home Pinball Machine, Jamie Fenton for Dave Nutting Associates

1976 Space Mission, Williams Electronic Manufacturing Company

1977 Atari 2600, Atari

1977 Star Wars: Episode IV: A New Hope, dir. George Lucas

1977 Sayre Glove, Dan Sandin, Tom DeFanti, Richard Sayre

1977 The Bally Astrocade, Bally

1977 Speak to Me Softly, Annette Barbier and Richard Mandeberg

1978 Phil Morton and Jane Veeder found the Electronic Visualization Center: "a television research: satellite orbiting the Art Institute Corporation - Chicago" (1978 - 1979)

1978 Diane Kirkpatrick curates the exhibition Chicago: The City and Its Artists 1945 - 1978 at the University of Michigan; the exhibition catalog includes an article on the collaborative work of Tom DeFanti, Phil Morton, Dan Sandin, and Bob Snyder

1978 Program #7, Phil Morton and Jane Veeder

1978 Program #9, Phil Morton and Jane Veeder

1978 3/78 (Objects and Transformations) by Larry Cuba produced using DeFanti's GRASS system at UIC

1978 BASIC ZGRASS: A Sophisticated Graphics Language for the Bally Home Library Computer, Jamie Fenton, Tom DeFanti, and Nola Donato

1978 Space Invaders, Taito, licensed by Midway Games

1978 Digital TV Dinner, Jamie Fenton, Raul Zaritsky and Dick Ainsworth

1978 Electronic Visualization Event (EVE 3) held at the University of Illinois at Chicago (UIC)

1978 ICRON, Bob Snyder

1978 Wire Trees with 4 Vectors, Phil Morton and Guenther Tetz (video), Leif Brush and Stu Pettigrew (audio)

1978 By the Crimson Bands of Cyttorak, Tom DeFanti and Barbara Sykes (video), Glen Charvat, Doug Lofstrom, Rick Panzer, and Jim Teister (audio)

1978 Spiral 3, Tom DeFanti, Phil Morton, Dan Sandin, and Jane Veeder (video), Sticks Raboin and Bob Snyder (audio) and Rylin Harris (dance)

1978 Data Bursts in 3 Moves, Phil Morton and Guenther Tetz (video) and Bob Snyder (audio)

1978 Cetacean, Phil Morton and Chip Dodsworth (video) and Barry Brosch (audio)

1979 Ars Electronica founded in Linz, Austria

1979 George Lucas hires Ed Catmull, Ralph Guggenheim, and Alvy Ray Smith to form Lucasfilm

1979 Spiral 5 PTL (Perhaps The Last), Dan Sandin, Tom DeFanti, and Mimi Shevitz

1979 The Digital Image Colorizer (DIC), Dan Sandin

1979 Wandawega Waters, Dan Sandin

1979 The Computer Museum in Boston (1979 - 2000)

1980 Sonia Landy Sheridan resigns from SAIC, signaling the end of its Generative Systems Program

1980 Barbara Latham becomes the head of the Video Area at SAIC

1980 Christine Tamblyn receives her BFA degree from SAIC

1980 Gene Youngblood teaches as a Visiting Professor in the Art History Department at SAIC

1980 Christine Tamblyn teaches as part-time faculty in the Video and the Performance Departments at SAIC

1980 Gene Youngblood interviews Phil Morton and Jane Veeder in Chicago

1980 Gorf, Jamie Fenton for COIN, Bally/Midway

1980 Real-Time Design ZGRASS Demo, Tom DeFanti, Jane Veeder, Raul Zaritsky, and Copper Giloth

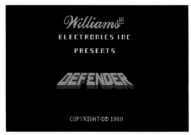

1981 Defender video arcade game, Williams Electronics

1981 Wizard of Wor, Midway

1981 SAIC Memo, Phil Morton

1981 MIDI (Musical Instrument Digital Interface) Specification (1981 / 1983 - present)

1981 Castle Wolfenstein, Silas Warner / Muse Software

1982 Tron video arcade game, Bally Midway

1982 WARPITOUT, Jane Veeder

1982 MONTANA, Jane Veeder

1982 Floater (The Final Sequence), Jane Veeder

1982 Commodore 64, Commodore Computers

1982 Ms Gorf (unreleased), Jamie Fenton for COIN, Bally/Midway

1982 Atari data glove, Atari

1982 SIGGRAPH '82 Art Show at SIGGRAPH '82, The Ninth Annual Conference on Computer Graphics and Interactive Techniques in Boston

1983 "Computer Art as a Way of Life," Gene Youngblood

1983 Christine Tamblyn leaves Chicago, relocating to New York City

1983 FLOATER, Jane Veeder

1983 ファミリーコンピュータ (Family Computer) or ファミコン (Famikon), AKA The Nintendo Entertainment System (NES), Nintendo (1983, 1985, 1986, and 1987)

1983 Dragon's Lair, Rick Dyer and Don Bluth

1983 Castle Smurfenstein, Andrew Johnson, Preston Nevins, and Rob Romanchuk

1984 Jamie Fenton, Marc Canter, and Mark Pierce form MacroMind corporation

1984 "The Digital Art: Computer art as a way of life - Jane Veeder" by Gene Youngblood is published in the Ars Electronica 1984 Festival Catalog

1984 Barbara Latham dies

1984 Apple Macintosh, Apple Computers

1985 MacroMind develops and releases MacroMind VideoWorks for the Macintosh computer

1985 VIZGAME, Jane Veeder

1985 "Tracking Video Art: 'Image Processing' as a Genre," Lucinda Furlong

1985 Tools for Thought: The History and Future of Mind-Expanding Technology, Howard Rheingold

1986 Jamie Fenton joins Apple Computer

1986 JG3D, Jane Veeder

1986 4KTAPE, Jane Veeder

1986 Paul Hertz graduates from SAIC

1986 The King of Chicago, Doug Sharp for Cinemaware/Master Designer Software

1986 MacPlaymate, Mike Saenz/Reactor Inc.

1986 Gramophone, Film, Typewriter, Friedrich Kittler

1987 MacroMind releases the Director multimedia authoring software released, the updated version of the previous application VideoWorks, giving birth to a wave of CD-ROM art production

1987 Jamie Fenton joins Alan Kay's Vivarium Project, developing "a number of prototype programming environments for children"

1987 The Interactive Image, Tom DeFanti and everyone from the EVL

1987 Digital Visions, Cynthia Goodman

1988 Jane Veeder hired as Full-time Faculty at San Francisco State University where she becomes Professor, Department Chair, and then Professor Emerita (as of 2018) of the School of Design in the Department of Design and Industry, College of Liberal and Creative Arts

1989 "chidoc: a snapshot of Chicago's electronic art community 1989," Claudia Cumbie-Jones and Lance Ford Jones

1989 The World Wide Web (WWW) Project developed by Tim Berners-Lee at The European Organization for Nuclear Research (CERN) in Genève, Switzerland

1989 "Cinema and the Code," Gene Youngblood

1990 "A Selected Chronology of Computer Art: Exhibitions, Publications, and Technology," Copper Giloth and Lynn Pocock-Williams

1990 A Volume of 2-Dimensional Julia Sets, Dan Sandin (computer graphics and RT/1 programming), Laurie Spiegel and Laurie Lou Kauffman (original music and audio effects), and Tom DeFanti (visual leadership)

1990 "Computer Art as Conceptual Art," Christine Tamblyn is published by Art Journal, College Art Association (CAA)

1990 Super Nintendo Entertainment System (SNES), Nintendo

1990 Virtual Valerie, Mike Saenz/Reactor Inc.

1991 CAVE, Dan Sandin, Tom DeFanti, Carolina Cruze Nevera, with Greg Dawl (industrial design) and everyone at EVL (1991 - present)

1991 Image Processing in Chicago Video Art, 1970-1980 by Christine Tamblyn is published by Leonardo, MIT Press

1991 Operation: Desert Storm, Alex Seropian for Bungie

1991 The Mind's Treasure Chest, Learn Television

1991 The Bard's Tale Construction Set, Interplay Productions

1991 Fractal Forest, Ellen Sandor, Stephan Meyers, Janine Fron and Craig Ahmer, (art)n (collaborative artists: John Hart; Special thanks: Dan Sandor, Tom DeFanti, and the EVL)

1991 Playing with Power in Movies, Television, and Video Games, Marsha Kinder

1992 Mosaic, the first Web Browser, developed at the National Center for Supercomputing Applications (NCSA) at the University of Illinois in Urbana-Champaign (UIUC)

1992 The JPEG (Joint Photographic Experts Group) standard (ISO/IEC 10918) for digital still image files created

1992 Mortal Kombat, Ed Boon, John Tobias, John Vogel and Dan Forden for Midway Games

1992 Apple Computers introduces QuickTime for digital video

1992 Wolfenstein 3D, id Software

1992 Ars Electronica, Phil Morton

1993 Inter Dis-Communication Machine, Kazuhiko Hachiya

1993 The European Organization for Nuclear Research (CERN) distributes the World Wide Web (WWW) Project in the public domain, releasing the following version with an open license

1993 Mosaic software is publicly released; its public release marks the beginning of our experiences of the World Wide Web (WWW) as known today

1993 The MPG-1 Standard (ISO/IEC 11172) by the Moving Picture Experts Group (MPEG) published

1993 Second Reality by Future Crew debuts at the Assembly 1993 demoparty in Kerava, Finland

1993 Mortal Kombat II, Midway

1993 DOOM, id Software

1993 Air on the Dirac Strings, George Francis, Louis Kauffman, and Dan Sandin (concept), Chris Hartman and John Hart (computer graphics), Jan Heyn Cubacub (dance), Dana Plepys (editor) and Sumit Das (music)

1993 She Loves It, She Loves It Not: Women and Technology, Christine Tamblyn

1993 Myst, Rand and Robyn Miller

1993 Penetrating into the Virtual World. Ways of Communicating with Interactive Art/ Möglichkeiten der Kommunikation mit Interaktiver Kunst, Erkki Huhtamo

1993 A Cyber Feminist Manifesto for the 21st Century, VNS Matrix

1994 JODI founded by Joan Heemskerk and Dirk Paesmans

1994 The visualization quest : a history of computer animation, Valliere Richard Auzenne

1994 Maya, Vibeke Sorensen

1994 Virtual Valerie 2, Mike Saenz/Reactor Inc.

1994 Marathon Trilogy, Bungie (1994 - 1996)

1994 All New Gen, VNS Matrix

1994 An Anecdoted Archive from the Cold War, George Legrady

1994 BAR-MIN-SKI: Consumer Product, Bill Barminski, Webster Lewin, and Jerry Hesketh

1994 Biomorph Encyclopedia: Muybridge, Nobuhiro Shibayama

1994 Meet the Media Band, the Media Band

1995 Osmose, Char Davies

1995 Arsdoom, Orhan Kipcak, Curd Duca, Rainer Urban, XRay, and collaborators

1995 DV (Digital Video) format

1995 IEEE 1394 Interface AKA FireWire, Apple Inc. (1394a/b), IEEE P1394 Working Group

1995 You Don't Know Jack, Jellyvision

1995 Jason Salavon works as PC and Playstation artist and programmer for Viacom New Media, Buffalo Grove (1995 -1997)

1995 Mortal Kombat 3, Midway

1995 Ultimate Mortal Kombat 3, Midway

1995 Surveying the First Decade: Video Art and Alternative Media in the U.S., Video Data Bank

1995 'Attention! Audience! Production! Performing Video in its First Decade, 1968-1980', Chris Hill

1995 "Resurrecting the Technological Past: An Introduction to the Archeology of Media Art," Erkki Huhtamo
90

1995 "Art on the CD-ROM Frontier," Erkki Huhtamo

1995 Cyberflesh Girlmonster, Linda Dement

1995 ScruTiny in the Great Round, Tennessee Rice Dixon and Jim Casperini with Charlie Morrow

1995 Future Interactive Fiction, Michael Nash

1995 Going Hybrid: The Online/CD-ROM Connection, Domenic Stansberry

1995 EVE 4, Alan Millman, Andrew Johnson, Christina Vasilakis, Dana M. Plepys, Deb Lowman, Jason Leigh, Jim Barr, Joe Insley, Kathy OKeefe, Maria Roussou, Misha Caylor, Terry Franguiadakis, Kaleung Jark, Dave Pape, Margaret Watson, Soyon Park, Kieth Beu, John Lawson, Satoshi Koreki, Marcus Thiebaux, Dave Swoboda, Tom Coffin, Milana Huang, Alan Verlo, Joe Reitzer, Jonas Talandis, and Anna Seeto at Gallery 400 (UIC)

1996 Untitled Game, JODI (1996 - 2001)

1996 ニンテンドウ64 (Nintendo 64), Nintendo

1996 Mortal Kombat Trilogy, Midway

1996 Duke Nukem 3D, Apogee

1996 Quake, id Software

1996 Museum Meltdown, Palle Torsson Tobias Bernstrup (1996 - 1999)

1996 My Boyfriend Came Back from the War, Olia Lialina

1997 Jason Salavon graduates from SAIC with a Master of Fine Arts degree

1997 Jason Salavon begins teaching as part-time faculty at SAIC (1997 - 2002)

1997 Mortal Kombat 4, Midway

1997 Mortal Kombat Mythologies: Sub-Zero, Midway

1998 Virtual Environment Workstation Project (VIEW), NASA's Ames Research Center

1998 Christine Tamblyn dies

1998 Dara Greenwald begins working at the Video Data Bank at SAIC

1998 The Intruder, Natalie Bookchin (1998 - 1999)

1998 Jason Salavon works as Nintendo 64 Artist & Programmer for Midway Games in Chicago (1998 - 2000)

1998 Half-Life, Valve

1999 SOD, JODI

1999 retroyou_nostal(G) series - retroyou, Joan Leandre (1999 - 2003)

1999 retroyou RC series - retroyou, Joan Leandre (1999 - 2001)

1999 CRACKING THE MAZE: Game Plug-ins and Patches as Hacker Art, Anne-Marie Schleiner

1999 Video Data Bank acquires the archive of the Videofreex

1999 DEADTECH Gallery run by Rob Ray in Chicago (1999 - 2008)

1999 ALLEGORIAL WORLDS, Jane Veeder

1999 Mortal Kombat Gold, Midway

1999 Bio Tek Kitchen, Josephine Starrs and Leon Cmielewski

1999 From Death's Door to the Garden Peninsula, Dan Sandin (virtual environment), Laurie Spiegel (sound), Dick Ainsworth (kayaking partner) and Tom DeFanti (Electronic Visualization partner)

1999 Child as Audience + Child as Participant (Where Technology and Anarchy Fuck), The Carbon Defense League, Critical Art Ensemble + Creation as Crucifixion

2000 Mario Battle No.1, Myfanwy Ashmore

2000 Mortal Kombat: Special Forces, Midway

2000 Career Moves, Mary Flanagan

2000 Adventures of Josie True, Mary Flanagan

2001 [rootings], Mary Flanagan

2001 Post-Data in the Age of Low Potential, Pt. 2, the first ever Beige gallery exhibition by BEIGE Collective at DEADTECH Gallery, Chicago

2001 gameboy_ultraF_uk, Baily & Corby (2001 - 2002)

2001 retroyou nostalG2 series - retroyou, Joan Leandre (2001 - 2003)

2001 The Film, Video, New Media and Animation Department (FVNMA) officially begins offering courses at SAIC, adding Animation [A] in 2010; FVNMA was formed by the merger of the previously separate Film and Video Departments

2001 The Language of New Media, Lev Manovich

2001 EVL Alive on the Grid, Dan Sandin, Josephine Anstey, Geoffrey Allen Baum, Drew Browning, Beth Cerny Patiño, Margaret Dolinsky, Petra Gemeinboeck, Marientina Gotsis, Alex Hill, Ya Lu Lin, Josephine Lipuma, Brenda Lopez Silva, Todd Margolis, Keith Miller, Dave Pape, Tim Portlock, Joseph Tremonti, Annette Barbier, and Dan Neveu

2001 Looking for Water, Dan Sandin (2001-2005)

2001 EVE5: Virtual Reality Art Environments in the CAVE, Beth Cerny Patiño, Brenda Lopez Silva, Dave Pape, John Landry, Joseph Tremonti, Josephine Anstey, Kyoung Shin Park, Petra Gemeinboeck, Tim Portlock, and Todd Margolis at EVL, UIC

2002 Super Mario Clouds, BEIGE Collective (Paul B. Davis, Cory Arcangel, Joe Beuckman, Joe Bonn)

2002 Jet Set Willy Variations, JODI

2002 Tale of Tales, Auriea Harvey and Michaël Samyn (2002 - 2015)

2002 criticalartware founded in Chicago (2002 - 2008)

2002 criticalartware interviews Kate Horsfield

2002 QQQ, nullpointer AKA Tom Betts

2002 Mortal Kombat: Deadly Alliance, Midway

2002 Emergency, Siebren Versteeg

2003 Jaywalker: The Game of Pedestrian Revenge, Anna Anthropy

2003 Rules of Play: Game Design Fundamentals, Katie Salen and Eric Zimmerman

2003 criticalartware interviews Dan Sandin

2003 criticalartware interviews Jane Veeder

2003 Phil Morton dies

2003 Dara Greenwald graduates from SAIC

2003 Dara Greenwald teaches as part-time faculty in the FVNMA Department at SAIC

2003 Old Skool Revolutionaries, jonCates' experimental documentary on the Media Art Hystories and Genealogies of Chicago, premieres at Conversations at the Edge, the Gene Siskel Film Center in Chicago

2003 Mortal Kombat: Tournament Edition, Midway

2003 Virtual Art: From Illusion to Immersion, Oliver Grau

2003 Emblem (2001: A Space Odyssey), Jason Salavon

2003 [domestic], Mary Flanagan

2003 The Artist Instrumentation Database Project, Mona Jimenez

2004 Max Payne CHEATS ONLY /, JODI

2004 Untitled Street Legal, JODI

2004 mario_is_drowning, Myfanwy Ashmore

2004 mario_doing_time, Myfanwy Ashmore

2004 jonCates hired as the first, and thus far only, full-time New Media Faculty at SAIC in the department of FVNMA, and Affiliated Faculty of the Art History, Theory and Criticism Department

2004 Mortal Kombat: Deception, Midway

2004 Half-Life 2, Valve

2004 Garry's Mod, Garry Newman

2004 Translator II: Grower, Sabrina Raaf

2004 [six.circles], Mary Flanagan

2005 Unity, Unity Technologies (2005 - present)

2005 Unity (1.0.0), David Helgason, Joachim Ante and Nicholas Francis

2005 criticalartware digitizes and distributes "The Distribution Religion," freely releasing digital copies of this document online

2005 Barb Abarmo donates the materials that will become The Phil Morton Memorial Research Archive to jonCates

2005 jonCates creates the concept of Chicago Dirty New Media Art while curating exhibitions and events called r4WB1t5 micro.Festivals in Chicago and Mexico City

2005 スーパープリンセスピーチ (Super Princess Peach) - Akio Imai and Azusa Tajima for Nintendo

2005 ENEMY run by Jason Soliday, Chicago (2005 - 2013)

2005 World Wide Wrong, JODI at Netherlands Media Art Institute (NIMk), Amsterdam

2005 Super Mario Movie, Cory Arcangel and Paper Rad

2005 Mortal Kombat: Shaolin Monks, Midway

2005 Everything I Do is Art, But Nothing I Do Makes Any Difference, Chris Reilly

2005 Game Design and Meaningful Play, Katie Salen and Eric Zimmerman

2005 The Game Design Reader: A Rules of Play Anthology, Katie Salen and Eric Zimmerman

2005 Everything, All at Once (Part III), Jason Salavon

2005 Fluxus (live coding environment), Dave Griffiths, Gabor Papp, and others

2006 From Counterculture to Cyberculture: Stewart Brand, the Whole Earth network, and the rise of digital utopianism, Fred Turner

2006 Oliver Grau founds the first international Media Art Histories Graduate program at the Donau-Universität Krems, Austria

2006 Dan Sandin: 35 Years of Electronic Art curated by jonCates and Amy Beste at Conversations at the Edge, the Gene Siskel Film Center in Chicago

2006 CALCULATIONS: PIONEERS OF COMPUTER ANIMATION curated by jonCates, Jim Trainor, and Amy Beste at Conversations at the Edge, the Gene Siskel Film Center in Chicago

2006 JODI curated by jonCates at Conversations at the Edge, the Gene Siskel Film Center in Chicago

2006 Mortal Kombat: Armageddon, Midway

2006 Mortal Kombat: Unchained, Midway

2006 First Person Shooter, Aram Bartholl

2006 [giantJoystick], Mary Flanagan

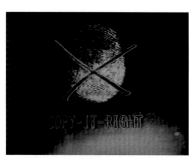

2007 COPY-IT-RIGHT curated by jonCates at Conversations at the Edge, the Gene Siskel Film Center in Chicago

2007 jonCates founds The Phil Morton Memorial Research Archive at SAIC

2007 The Distribution Religion exhibition at The Art Gallery of Knoxville, Tennessee

2007 The Grassroots Video Pioneers, Dara Greenwald (2007)

2007 Jason Salavon begins teaching as an Assistant Professor in the Department of Visual Arts & Computation Institute, The University of Chicago (U of C) (2007 - 2014)

2007 Ultimate Mortal Kombat, Midway

2007 Tamas Kemenczy graduates from SAIC

2007 gameboy portraits - portable family -, Myfanwy Ashmore

2007 Native Dance Vibrations, Nancy Bechtol

2008 Mighty Jill Off, Anna Anthropy

2008 Calamity Annie, Anna Anthropy

2008 Sidequest: Text Adventure and Games Walkthrough Gallery Show, The Guardians of the Tradition, an Art Games guild (jonCates, Jake Elliott and Tamas Kemenczy)

2008 Eugene Jarvis is DePaul University's first Game Designer in Residence

2008 Mortal Kombat vs. DC Universe, Midway

2008 SIGGRAPH Asia (SA) conferences begin

2008 "Dirty New Media: Art, Activism and Computer Counter Cultures," Jake Elliott

2008 GLITCH: Creative Problem Creating curated by Jon Satrom at Conversations At The Edge, attended by Nick Briz

2008 I LOVE PRESETS (Jon Satrom, Jason Soliday and Rob Ray) at Conversations at the Edge, The Gene Siskel Film Center, organized by jonCates

2008 "Graphical Performance Machines: Computer Graphics as a 'way of life,'" Michael Century

2009 Afternoon in the House of Secrets, Anna Anthropy

2009 When Pigs Fly, Anna Anthropy

2009 Digital Broadcast standards switch over in the United States, transitioning signals from analog to digital and introducing digital glitches into broadcast media/television

2009 The Collapse of PAL, Rosa Menkman

2009 jonCates is the first graduate of the first international Media Art Histories Graduate program at the Donau-Universität Krems, Austria

2009 CRITICAL GLITCH ARTWARE (2009 - 2013)

2009 Glitch: Investigations into the New Ecology of the Digital Age curated by Nick Briz at Eye&Ear Clinic, Chicago

2009 James Connolly graduates from SAIC

2009 Critical Play: Radical Game Design, Mary Flanagan

2009 [xyz], Mary Flanagan

2010 A House in California, Jake Elliott

2010 Hummingbird Mind, Jake Elliott

2010 I Can Hold My Breath Forever, Jake Elliott

2010 Beulah and the Hundred Birds, Jake Elliott

2010 Dog and Bone are Friends, Jake Elliott

2010 Pong Vaders, Anna Anthropy with Koduco

2010 Redder, Anna Anthropy with Koduco

2010 Critical Glitch Artware curated by jonCates and Jake Elliott at BLOCKPARTY and NOTACON Art and Technology conference/hacker convention in Cleveland

2010 GLI.TC/H (Glitch Art) Festivals of Noise and New Media in Chicago (2010 - 2012)

2010 Rosa Menkman: Glitched at Conversations at the Edge, The Gene Siskel Film Center, organized by jonCates

2011 Art Games LAN Party curated by jonCates, Jake Elliott, and Tamas Kemenczy at NOTACON Art and Technology conference/hacker convention in Cleveland

2011 Balloon Diaspora with music by Oliver Blank, Jake Elliott

2011 Cracked Ray Tube, James Connolly and Kyle Evans (2011 - 2018)

2011 Nick Briz graduates from SAIC

2011 Jake Elliott graduates from SAIC

2011 Lesbian Spider Queens of Mars, Anna Anthropy

2011 Police Bear, Anna Anthropy

2011 Encyclopedia Fuckme and the Case of the Vanishing Entree, Anna Anthropy

2011 Arcanebolt, Mark Beasley, Tamas Kemenczy, and Alex Inglizian (2011 - 2015)

2011 Mortal Kombat, NetherRealm Studios

2011 Mortal Kombat Arcade Kollection, Other Ocean Interactive

2011 Jeff Koons Must Die!!!, Hunter Jonakin

2011 Barb Abramo dies

2012 Dirty New Media Toolkit developed by jonCates, Jake Elliott, and SHAWNÉ MICHAELAIN HOLLOWAY for NOTACON Art and Technology conference/hacker convention in Cleveland

2012 DNMw3rkstati0n:: (AKA Dirty New Media Workstation) curated by jonCates, Jake Elliott and SHAWNÉ MICHAELAIN HOLLOWAY for the GLI.TC/H (Glitch Art) conference of Noise and New Media Art in Chicago

2012 Glitch / Artware Category created by jonCates, Jake Elliott and Tamas Kemenczy for PixelJam at NOTACON Art and Technology conference/hacker convention in Cleveland

2012 jonCates proposes and publicly deploys the concept of postglitch

2012 Dara Greenwald dies

2012 Keep Me Occupied, Anna Anthropy

2012 Rise of the Videogame Zinesters: How Freaks, Normals, Amateurs, Artists, Dreamers, Drop-outs, Queers, Housewives, and People Like You Are Taking Back an Art Form, Anna Anthropy

2012 Dys4ia, Anna Anthropy

2012 Anna Anthropy presents at dorkbot Chicago on Thursday April 5th 2012 at 7 PM, organized by jonCates and Jake Elliott

2012 Nick Briz begins teaching as part-time faculty at SAIC

2012 Jake Elliott begins teaching as part-time faculty at SAIC

2012 CH1CΔGø D1RTY N3W M3DIΔ curated by Nick Briz at The Museum of Contemporary Art, Chicago

2012 Mortal Kombat: Komplete Edition, NetherRealm Studios

2013 Triad, Anna Anthropy

2013 The Hunt for the Gay Planet, Anna Anthropy

2013 And the Robot Horse You Rode In On, Anna Anthropy

2013 *Kentucky Route Zero, Cardboard Computer* (Jake Elliott, Tamas Kemenczy, and Ben Babbitt) (2013 - present)

2013 (Glitch) Art Genealogies curated by Daniel Franke, John McKiernan and Rosa Menkman at LEAP Gallery, Berlin

2013 Dirty New Media curated by Antonio Roberts at The Barber Institute of Fine Arts, Birmingham

2013 "Re:copying-IT-RIGHT AGAIN" by jonCates published in Re:live: New Directions in Media Art History, edited by Sean Cubitt and Paul Thomas, MIT Press

2013 REMIX-IT-RIGHT! curated by jonCates at the Gene Siskel Film Center, as part of Conversations At The Edge with the Society for Cinema and Media Studies Annual Conference

2013 Apple Computers, Nick Briz; commissioned for REMIX-IT-RIGHT!

2013 James Connolly begins teaching as part-time faculty at SAIC

2013 SHAWNÉ MICHAELAIN HOLLOWAY graduates from SAIC

2013 Damsel in Distress: Part 1 - Tropes vs Women in Video Games - feministfrequency, Anita Sarkeesian

2013 "Venus in Glitches: Dirty New Media and Transdiscursiveness," SHAWNÉ MICHAELAIN HOLLOWAY

2013 1_approach.dnm: (inter)active viewership in dirty new media, SHAWNÉ MICHAELAIN HOLLOWAY and Steven R. Hammer

2013 Video Game Art Gallery (VGA Gallery) is founded by Chaz Evans and Jonathan Kinkley and holds its first exhibition at Galerie F, Chicago in August 2014

2014 glitChicago curated by Paul Hertz at the Ukrainian Institute of Modern Art, Chicago

2014 "Phil Morton and Jane Veeder: Our Desired Futures and the Mobile Media Art Lab," by jonCates published in Immersive Life Practices, edited by Daniel Tucker, University of Chicago Press

2014 "Copying-It-Right: Archiving the Media Art of Phil Morton," by jonCates published in The Emergence of Video Processing Tools: Television Becoming Unglued, edited by Mona Jimenez, Kathy High, and Sherry Miller Hocking, Intellect Books

2014 RGB.VGA.VOLT, James Connolly (2014 - 2018)

2014 Gay Cats Go to the Weird Weird Woods, Anna Anthropy

2014 ZZT, Anna Anthropy

2014 Jason Salavon becomes Associate Professor, Department of Visual Arts & Computation Institute, University of Chicago

2014 ANALOG DREAMSCAPE: Video & Computer Art in Chicago 1973-1985 - South Side Projections with Institute for the Humanities at UIC

2014 VGA Gallery incorporated into a not-for-profit organization

2015 International Symposium on Electronic Art (ISEA) takes place in Vancouver, Canada, featuring a Glitch Art category/track

2015 Ohmygod Are You Alright, Anna Anthropy

2015 Glitch Art is Dead Festival/exhibition/conference at Teatr Barakah in Krakow, Poland

2015 /'fu:bar/ glitch art izložba, Siva Galerija, AKC, Zagreb, Croatia

2015 Mortal Kombat X, NetherRealm Studios

2016 Celebrating Women in New Media Arts | 150 Years of SAIC symposium at SAIC

2016 Radiant Visions: Media Art from SAIC, 1965 – Now curated by jonCates, Daniel Eisenberg and Amy Beste at SAIC

2016 Mortal Kombat XL, NetherRealm Studios

2017 Glitch Art is Dead Festival/exhibition/conference at Gamut Gallery in Minneapolis, MN

2017 Everything but the Clouds, Patrick LeMieux

2017 "The BEIGE Programming Ensemble: An Essay," Randall Roberts

2017 Have a Nice Day II: VR Tour Through the Decades, Ellen Sandor, Chris Kemp, Diana Torres, and Azadeh Gholizadeh, (art)n, n Memory of Martyl (special thanks: Janine Fron; Code: William Robertson; Narration: Rachel Bronson, Bulletin of the Atomic Scientists)

2017 VGA Gallery opens a brick-and-mortar location in Chicago

2017 VGA Gallery launches the first publication of The Video Game Art Reader, a peer-reviewed, open-access, academic journal of video game art scholarship

2018 It is two minutes to midnight exhibition by Ellen Sandor, (art)n, and collaborators at Weinberg/Newton Gallery in Chicago

2018 New Media Futures: The Rise of Women in the Digital Arts, Ellen Sandor, Donna Cox, and Janine Fron (co-editors)

2018 "Idealisms of Do-It-Yourself Media Arts: From Portapak to Internet," jonCates

2018 Un Pueblo de Nada (*Kentucky Route Zero* interlude), Cardboard Computer (Jake Elliott, Tamas Kemenczy, and Ben Babbitt)

Phil Morton and Guenther Tetz (Video), Lief Brush and Stu
Pettigrew (Audio)
Wire Trees with 4 Vectors, 1978
Video

Index

About Video Game Art Gallery

Founded in 2013 in the lively game community of Chicago, Video Game Art (VGA) Gallery seeks to increase cultural appreciation, education of video games and new media through exhibition, study, critique, and sale. Annual programs include Exhibitions and Events featuring the work of significant artists and game developers from around the world; Education programs are comprised of talks, screenings, and student programs; the VGA fine art print collection encompasses giclees and posters of artwork from video games; and a scholarly publications program that includes the VGA Reader, a peer-reviewed journal that highlights new scholarship about video games and new media art. VGA Gallery is an Illinois 501(c)(3) not-for-profit corporation.

VGA® is a registered trademark of VGA Foundation.